WELCOME TO

Art Class

Your Name _____ Period _____

Class: _____

You will use this ALL year!

DO NOT LOSE IT

Teacher Edition

The Art Student's Workbook

A Classroom Companion for Painting, Drawing, and Sculpture

Fifth Edition, Soft Cover, Teacher Edition

Copyright 2011
By Eric Gibbons

ISBN: 1463753896
EAN-13: 978-1463753894

Printer: Createspace
Publisher: Firehouse Publishing, www.firehousepublications.com

This book is dedicated to: Dr. Chris Craig of the College of NJ for showing me that teaching art could be more than I had ever imagined. To Ken Vieth who showed me what an art room could be. To my students who inspire me to continue being a teacher.

Special thank you to R. T. Berry for editing assistance.

Student Achievement & Relevance

In a time when the economy is strained and schools must choose to make cuts, it is often the art department that is the first to suffer as it is considered peripheral "fluff" or a dumping-ground.

There is a wealth of evidence that a rigorous arts program benefits students. It may be the problem solving methods we use daily, or our natural "backwards design" approach that helps our students succeed. Art teachers know that these same concepts are what we already do, but they are only recently coming into the light as the new "cutting edge" of education. I think it is this and more.

Informal evidence from my school's guidance department indicates that students who take my course are 50% LESS likely to fail standardized testing. This is information that can grab the attention of your administration and Board of Education.

Art is the one class where the concepts of math, science, history, language, and writing can converge in a well-orchestrated, rigorous, and relevant program. We not only come to understand the concepts but we use them and manipulate them for deeper understanding on multiple sensory levels of thinking. I have divided this workbook by multicurricula units so that this concrete connection to academic core courses is more easily seen.

Does an art class lose its creative edge by incorporating other subjects? My twenty years of experience tells me that this integration enhances it. Students have a deeper understanding of the work, they come to see the relevance, and are more likely to "buy into" the concepts. When students ask, "Why do we have to know this stuff?" the answer becomes relevant through our daily approach, process, and end products.

ALL projects herein are designed to have successful divergent results, incorporate creative problem solving, and bring relevant connections to students' lives. This book is built for student success on many levels from gifted to challenged. This in turn is helpful in fulfilling mandated state and federal accommodations so that *no child is left behind*.

~ Eric Gibbons

Teacher Workbook Contents

Rules & Expectations 7
Elements of Art 9/125
Principles of Art 10/120
Expressive Color & Shape 15/121
Material, Care, & Safety 21
Self Expression 26
Math & Geometry in Art 44
Economics & Art 57
Perspective 58
Facial Proportions 71
Science Concepts & Art 73
Engineering & Art 78
Da Vinci & Inventions 80
World Cultures & Diversity 88
Service Learning & Awareness 97
English & Literature 106
Composition & Analysis 111
Vocabulary & Reference 120
History & Research 126
Visual Analysis 136

---- Teacher Edition Only ----

Video Resources 148
Intercurricular Lessons 151
Sketchbook Concepts 164
Project Rubrics 170
Supplies List & Suggestions 173
The Tao of Teaching Art 175

Student Workbook Contents

Rules & Expectations 6
Elements of Art 7
Principles of Art 8
Expressive Color & Shape 16
Material, Care, & Safety 21
Self Expression 26
Math & Geometry in Art 42
Economics & Art 50
Perspective 51
Facial Proportions 64
Science Concepts & Art 66
Engineering & Art 71
Da Vinci & Inventions 73
World Cultures & Diversity 80
Service Learning & Awareness 88
English & Literature 96
Composition & Analysis 100
Vocabulary & Reference 109
History & Research 115
Visual Analysis 125
Project Notes 139
Project Sketch Pages 146
Video Notes 162
Project Rubrics 174
Pass Points (4 per year) 179

Suggested Timeline of Instruction

1st Quarter: Art Elements and Color Vocabulary/Theory

2nd Quarter: Art Principles of Design

3rd Quarter: Art History

4th Quarter: More Art History, Research, and Careers in Art

Student Workbooks DO NOT include lessons or as many samples.

Welcome to Art Class

Think of this as your OASIS from the rest of the school. When we are in this room, the rest of the school rush is not here. If you have difficulty elsewhere, this can be the one place where you can really shine. Be present; enjoy creating. No answer to a problem is wrong. Don't be an artist, be yourself, and be OPEN to creative possibilities!

The rules in this room come down to one word... **RESPECT**
> ...For the teacher
> ...For each other
> ...For the materials that we use.

> _____ % of your grade is based on project work, (1 project will be "participation")
> _____% is based on written work and tests/exams
> _____% is video notes or homework
> _____% depends on a quiz

*EVERYONE Starts with 100% as a participation grade. Up to 10 points are deducted for a day you choose to not participate if you do not have a pass point coupon. (See last page of your book.)
There is a Major Exam at the end of the each semester that will average into your grades.

Projects are graded on an average of the following 5 criteria:

Neatness: NOT folded, ripped, cracked, and no smudges, not having a hurried or messy look.
Completeness: No empty areas. Have complete color, consistent handling, and all required elements.
Originality: Not copied, 100% your own idea. BONUS for uniqueness!
Following Directions: Going step by step, not skipping steps, shortcuts generally don't help.
Conduct: Were you helpful, or did your behavior keep others from success?

NOWHERE do we require work to be "pretty" or somehow a great work of art. NOT everyone is an ARTIST, but if you are neat, complete, original, follow directions, and are respectful, you can get an "A." Your grade is based on the PROCESS rather than the product. If you TRY your projects will not FAIL.

ANYTHING is better than a ZERO. Even an "F" is _____ points. A zero is nothing. Generally if you are missing just one project, passing is nearly impossible. Some projects are worth MORE than 20% of your quarter's grade. PARTICIPATION is key. If you show effort every day, your projects will not fail.

Video Notes may be given from time to time to fill your art history requirements or technical information in this class. For every video you will need to write some facts about what you viewed. You may write statements made in the video, or things you observed. Statements like "The artist is a boy" or "Paints" are not acceptable. One or two word statements are NOT FACTS and will count as a ZERO. These assignments are VERY easy.

> — As with all classes you are required to be on time every day
> — IF you think you MIGHT be late, get a pass! You will receive a detention tardy # _____ .
> — Have a pencil EVERY DAY.
> — Turn OFF your cell phone. If you must use it for an emergency, ask for a pass to the office.

The rule about personal listening devices is _____

ALSO: _____

It is ALWAYS your responsibility to make up any missing work. You might not be reminded... you need to see the teacher when you return and make up assignments. **ALL missing work will count as a ZERO.**

Teachers Please Note

Most of the following worksheets are repeated in the back of the book with answers filled in. This is true in the student edition as well so that those with incomplete answers can have complete information for exams and tests.

This is helpful too for students with special needs that you are required to provide additional study guides and information for. In this way their families may help them study.

Though the answers are in the back, I would not share that with the students until right before a test. Most do not explore their workbooks enough to know that many answers are there.

Additionally, this workbook is designed to be used with the textbook, *The Visual Experience,* which I highly recommend. Be sure if you buy it you get a version with the co-author Ken Vieth, as it will also include many lesson ideas. However, if you cannot get access to these textbooks, all of the worksheets can be answered with standard dictionaries, encyclopedias, or the internet.

Please tell students to write their name on the inside cover, spine, and on all "pass-points" at the rear of their books with a color permanent marker. This will help avoid loss or theft.

Overview of 8 Art Elements

A line is a _____ moving through _____. We can measure the _____ of a line and nothing else, therefore it is _____ dimensional or ___ -D.

A _____ that intersects itself will create a shape. A shape is _____ dimensional. There are _____ basic shapes. The one with the fewest number of sides is the _____. The one with the most sides is the _____.

A _____ that moves in _____ can create a form. There are ___ basic forms. The one with the fewest amount of sides is the _____, the one with the most sides is the _____.

There are ___ basic colors. Basic colors are also called _____ colors. When these basic colors mix they create _____ colors of which there are ____. Color is _____ light. Orange, red and yellow are considered _____ colors, while blue, green, and purple are considered _____ colors.

_____ refers to the weight of something; sometimes it is real and sometimes it is the way it looks. A _____ colored box will look heavier than a _____ colored one.

The roughness or smoothness of a surface refers to its _____. It can sometimes be made by repeating an art _____ many times.

All objects, art and non-art, take up _____. Many art elements move through it. This art element comes in 2 types, they are _____ meaning where the object IS, and _____, meaning where the object is NOT.

The art element of _____ helps us see all other art elements. We see everything because it is _____ off of an object or surface and back to our eye. When it is NOT bounced back to us we see _____.

Principles of Art & Design *(Crystal video is titled Principles of Art)*

1. What does **balance** mean?

2. Symmetrical Balance

3. Asymmetrical Balance

4. What does **movement** mean?

5. What is a focal area?

6. Does a sculpture actually have to move to have "movement?"

7. How does the painting of the house achieve movement?

8. What is **rhythm**?

9. It organizes space through _____

10. Does it have to be regular (predictable)?

11. What is **contrast**?

12. What is the opposite of contrast?

Continued…

13. Name 5 kinds of contrast are used in the Cézanne painting? (There are 8)

14. What is **emphasis**?

15. Should the focal point be centered in an artwork?

16. Where should it go?

17. How does the artist create emphasis in his picture of the flower?

18. What is **pattern**?

19. What kind of artists use pattern?

20. What two kinds of patterns are possible?

21. What is **unity**?

22. What is the opposite of unity?

23. What are 3 ways unity can be achieved in a work of art?

PRINCIPLES OF DESIGN WORKSHEET

Using the glossary of *"The Visual Experience"* textbook and information from pages 166 to 205, please define the following giving an example of each. **Teacher: Students can use dictionaries, internet, or other.**

(page 172) Define UNITY:

Give one example of this principle not in the book, so I know you understand it:

(page 174) Define VARIETY:

Give one example of this principle not in the book, so I know you understand it:

(page 176) Define EMPHASIS:

Give one example of this principle not in the book, so I know you understand it:

(page 178) Define RHYTHM and MOVEMENT:

Give one example of this principle not in the book, so I know you understand it:

(page 184) Define BALANCE:

Give one example of this principle not in the book, so I know you understand it:

Continued...

(page 188) Define PATTERN:

Give one example of this principle not in the book, so I know you understand it:

What is a MOTIF?

(page 190) Define PROPORTION:

Give one example of this principle not in the book, so I know you understand it:

What is the difference between PROPORTION and SCALE?

(page 192) Look at the image. Please list 3 art principles you can see in this artwork and how you know it to be true. Be specific so I know you understand it.

Art Principles Worksheet *(Student Workbook has 4 pages like this)* (tiny sketch below)

The artwork sample is called:

by _____.

It is from the _____
School of art. Please describe in FULL sentences
how you see the art principles used in his image.

Explain how the artist uses UNITY and where you see it used. Be Specific.

Explain how the artist uses VARIETY or CONTRAST and where you see it used. Be Specific.

Explain how the artist uses EMPHASIS or DOMINANCE and where you see it used. Be Specific.

Explain how the artist uses RHYTHM and/or MOVEMENT and where you see it used. Be Specific.

Explain how the artist uses BALANCE and where you see it used. Be Specific.

Explain how the artist uses PATTERN and where you see it used. Be Specific.

Explain how the artist uses PROPORTION and where you see it used. Be Specific.

Emotional Values of Shapes and Colors

```
┌┄┄┄┄┄┄┄┄┄┐
┊   See    ┊        △
┊ rear of  ┊
┊  book    ┊        ○
└┄┄┄┄┄┄┄┄┄┘
                    □
```

Associations: _____

Emotional: _____

Associations: _____

Emotional: _____

Associations: _____

Emotional: _____

Red: Associations: _____

 Emotional: _____

Orange: Associations: _____

 Emotional: _____

Yellow: Associations: _____

 Emotional: _____

Green: Associations: _____

 Emotional: _____

Blue: Associations: _____

 Emotional: _____

Purple: Associations: _____

 Emotional: _____

Black: Associations: _____

 Emotional: _____

Brown: Associations: _____

 Emotional: _____

White: Associations: _____

 Emotional: _____

Draw combination of shapes to represent yourself.

Using the color information on the previous page, color in
that shape in a way that describes you.

FAMILY

Describe 8 to 10 people in your family including yourself. Include both strengths and weaknesses. ALWAYS begin with people living in your household, and then extend that list into family not living with you. You may include people you knew who have died. **If you do not want to list names, use a nickname or initial so YOU know who you are writing about.**

1. _____ : _____

2. _____ : _____

3. _____ : _____

4. _____ : _____

5. _____ : _____

6. _____ : _____

7. _____ : _____

8. _____ : _____

9. _____ : _____

10. _____ : _____

Family can be represented abstractly in either 2-D or 3-D

The first sample is a watercolor painting where all family members are represented with shapes and color. Overlaps show the relationships between people. The second sample is a mobile of a family unit, where form and color represent each member of the family.

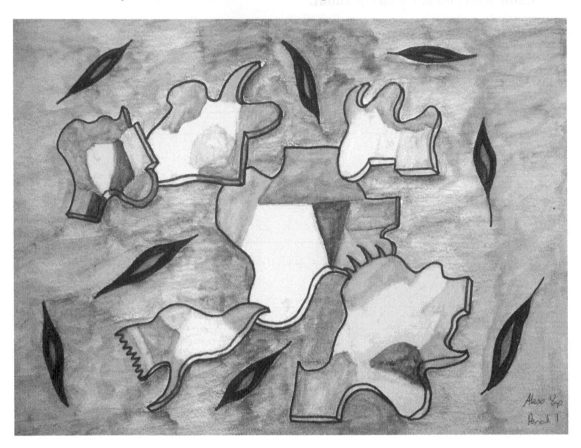

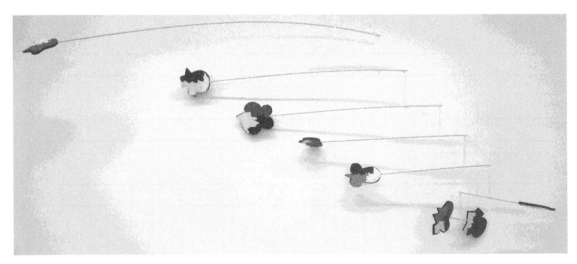

Color Vocabulary

Please use **The Visual Experience** book to answer and define the following. (Starting on page 92) This may be a graded assignment, like an open book quiz.

Value (page 92)

Shading (page 93)

Chiaroscuro (page 93)

Spectrum (page 96)

Hue (page 96)

Primary Colors (page 97)

Secondary Colors (page 97)

Intermediate Colors (page 97)

Complementary Colors (page 97)

Triadic Colors (page 102)

Monochromatic Colors (page 98)

Intensity (page 98)

Color Harmonies (page 100)

Analogous Colors (page 101)

Warm Colors / Cool Colors (page 102)

COLOR WHEEL →

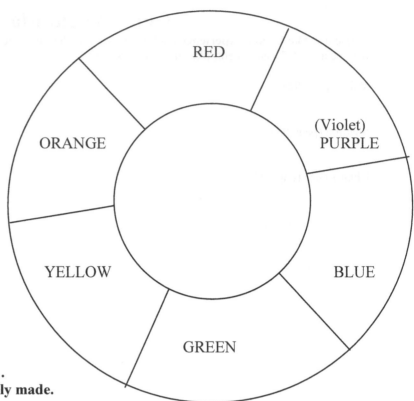

Use only the 3 primary colors to color in this diagram →

Guess what the mix will be first…
Then try it and write what it really made.

Red + Blue = _____ (_____)

Blue + Yellow = _____ (_____)

Yellow + Red = _____ (_____)

Red + Blue + Yellow = _____ (_____)

Orange + Blue = _____ (_____)

Purple + Yellow = _____ (_____)

Green + Blue = _____ (_____)

*Black + Yellow = _____ (_____) | *= not on test |

* Black + Yellow + Red = _____ (_____)

* White + little Red + little Yellow + VERY little Black = _____ (_____)

Spectrum colors in order _____

Coloring Expectations

There is no reason to rush your work. We are more concerned with the process than what it looks like at the end. If the process is good then the product should be fine. When you rush things like coloring, it can damage the neatness and completeness portion of your grade. Though you may have been coloring for years, maybe since before you even came to school, there are a few things to keep in mind:

— You should use SMALL parallel strokes to color in
— The pressure you apply will determine the color intensity
— Try to stay within the boundaries you have set. (Stay in the lines)
— You should always color in layers. Nothing is the same color as a crayon
— Try shading with a neighboring or opposite color before choosing black
— Be patient, good work takes time

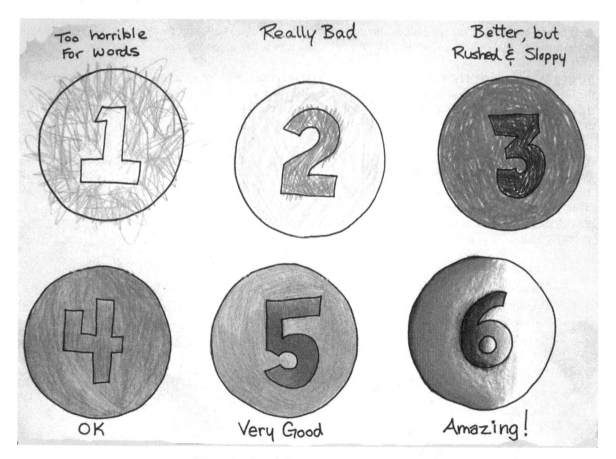

Though not every student is artistic, we expect all our students to strive to do their best. The back of this book has a color version of this expectation chart.

COLOR BIAS

In a perfect world Yellow and Red make Orange… and they do, sometimes.

Why not always??? Color is not perfect. It is made from minerals and chemicals and nothing in nature or on this earth is 100% perfect yellow. Some yellows are a bit orange, like a bright sunny yellow, and some are a bit green like lemon yellow.

ALL colors "**LEAN**" a bit one way or another. This is called **Color Bias**. Some companies even label their paint so you can see which way the color "leans," When mixing colors, you need to choose colors that "lean" towards each other. If you do not, your colors will be less bright and even brown-ish. (This might be a good thing when painting natural elements like dirt, grass, bark, rocks etc…)

Color bias can work for you or against you, but you need to use it to your advantage.

<u>**AVOID BLACK**</u> in your paintings of nature. It is better to mix color opposites or compliments to make a dark tone. There is very little black in nature. Burnt wood/charcoal is black, some deep dark shadows may need black, but 90% of the time black should be avoided. It is often the easiest way a professional can spot amateur work. Black kills color and only in a few instances is this a good thing.

<u>**Mixing Watercolors:**</u> The lids of most watercolor sets are detachable for a reason… you can mix colors on the lid, but separate it to clean it. HOWEVER when painting a landscape, SOMETIMES it's better to mix right on the paper so the color is uneven. Nature is organic and does not have perfect colors. Imperfections in your paint mixtures might be a desirable effect.

Paint Brush Care

Paint brushes are an important tool in an artist's toolbox. They are expensive and need to be cared for properly. Some paints, like acrylics, can ruin brushes if they are not cleaned properly.

- — Always use COLD water to clean a brush
- — Hot water melts the glue that holds the brush together
- — Be sure to wash the collar of the brush too
- — Test your clean brush on paper before storing
- — Store brushes with the brush-end-up

BRUSH COLLAR HANDLE

PLASTER WORK

Plaster is activated by water. It is important to be aware of how you set up your area for plaster work.

1. Cover your table area with paper or plastic. Remove jewelry.

2. Keep plaster and water far enough away that the water won't accidently splash, drip, or spill on the plaster.

3. Be sure others near you won't interfere with your set-up or cause an accident as well. Several people can work from one bucket.

Once plaster has been dipped in water, it must be strained through the fingers and applied to your base or object to be covered. Plaster will need to be 2 or 3 layers thick to be strong.

If you accidently get water on a plaster strip, use it immediately.

Plaster cannot be re-used once it has hardened.

Smooth strips with your hands as you apply them. Without smoothing, one layer will not bond with the last.

NEVER put plaster down a sink. Not from your hands, not from the bucket. It will form stones in the pipes and be VERY expensive to repair.
— Wash hands in plaster water first
— Stir plaster in bucket with hands and dump in to grass or dumpster
— Let bucket dry and crack plaster into garbage

Though plaster will come out of clothes, you may find wearing a smock is good protection.

Liquid Plaster

Plaster is activated by water. It is important to be aware of how you set up your area for plaster work.

1. Cover your table area with paper or plastic. Remove jewelry.

2. Keep plaster and water far enough away that the water won't accidently splash, drip, or spill on the plaster.

3. Be sure others near you won't interfere with your set-up by accident as well. Several people can work from one bucket.

Determine how much liquid plaster you need (cup or bucket). Use LESS THAN HALF that amount of water.

Hot water hardens plaster faster than cold water; choose accordingly.

Add dry plaster with a cup or scoop or spoon by sprinkling a little at a time. Too much at once will ruin your plaster mixture. Be sure to sprinkle evenly all around your container so it fills evenly. DO NOT STIR THE MIXTURE!

Slowly add plaster until it forms islands in the water that do not go below the surface of the water. See picture above.

Once you have sufficient islands, you may stir. The more you stir the faster the plaster will harden. *(FYI: Plaster heats up as it dries; use caution if applying to body)*

NEVER put plaster down a sink. Not from your hands, not from the bucket. It will form stones in the pipes and be VERY expensive to repair.
 — Wash hands in plaster water first
 — Let bucket dry and crack plaster into the garbage. Toss cups.

Hint: *Acrylic paint or acrylic medium can be added to plaster. Acrylics make the plaster dry mush more slowly. Add 1/10 of acrylic medium to the water **before** adding plaster.*

Razor Blades
SAFETY

ALWAYS get permission to use any sharp tools.
- NEVER play with these tools.
- Taking one out of the classroom is ILLEGAL and considered a weapon in school.
- Check that the blade is secure and tight.
- Keep it capped when not in use.
- Protect table when cutting.
- ALWAYS cut away from fingers or body.
- Hold like a pencil for best control.

IF YOU GET A CUT...
- Hold cut tightly closed.
- Tell teacher immediately.
- Wash with running water.
- Pinch closed with paper towel.
- See teacher for band-aid or hall pass to the nurse.

GLUE GUN
SAFETY

GLUE GUNS can heat up to about 400 degrees. They will burn deeply.
NEVER touch the tip of a glue gun. EVEN the glue that comes out can burn badly. Use a craft-stick to move the glue if you need to. Glue guns stay hot for a while after being unplugged! A glue gun is NOT A TOY!

IF YOU GET BURNED, go to the sink quickly and rinse with cool water. If you get a blister, get a pass to the nurse.

Self-Expression

Many of our projects are based on expressing your own thoughts and feelings in a visual way.

List some things here that people know about you:
(Talents, skills, personality traits, awards, hobbies, likes or dislikes…)

List things that most people do not know about you:

List things people think about you that are NOT true:

Do you have a secret about yourself that nobody knows? It's okay to write this in code if it is embarrassing, or write some key words about it that only you understand.

Goals

What are some life goals you have? Things you hope to achieve in the future.

— By the time I graduate from high school, I hope to have :

— In 10 years I hope I have :

— In 20 or 30 years I hope I have :

— Before I die, I hope that I have :

List some things that can hold you back from reaching your goals:

1.

2.

3.

4.

5.

6.

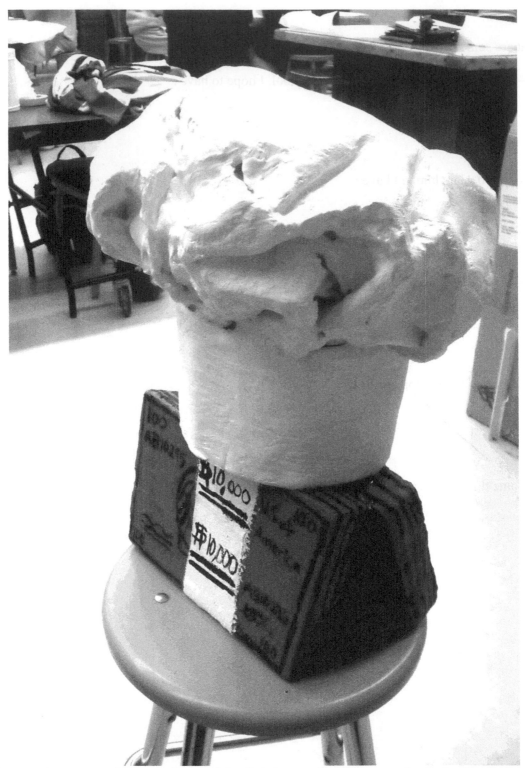

The student's sculpture shows his GOAL to be a great chef; the base is the thing that could hold him back. It is the money to go to a good college.

Phobias

List 5 things you have a fear of

1.

2.

3.

4.

5.

List 5 things others may fear but you do not.

1.

2.

3.

4.

5.

Come up with symbols for each.

Hands
We use objects and symbols every day. Trace your hands 4 times, overlapping, then go back in and fill in simple details like nails and main wrinkles. Be sure to include 4 important symbols that relate to you or the things you value.

Consider what you will put in the center. Will you overlap letters of your name, create a single important symbol or do a self portrait? It's up to you.

Where lines overlap making new shapes, color in each shape a different color. This is a great time to learn to blend colors. Try using only primary colors and have white available as a bonus color. Because our lines are black, black color is not an option for this project.

Masks

Masks are usually used to hide the identity of the wearer. However, in this project, we are going to design a mask that will show others a side of you that you normally keep hidden from others, or something people don't normally know about you. This can be done through using symbols and shapes that you can either paint on the mask, or shape the mask to look like. So, if people assume you are kind of "ditzy" but you're really smart, you can shape the mask into the shape of an owl to represent how smart you are.

1. Sketch out how you want your mask to look including any symbols that you might paint on to the mask. Also, write down the meaning of your symbols as a reminder for yourself if you have a number of symbols that you are painting unto the mask.

 REMEMBER: This can be a mask that can be worn OR a mask that is simply decoration on a wall. You should decide what kind it will be before you begin , so you'll know how to build it.

2. We will create a foam base and build up the features on the face. Aluminum foil works too. WARNING: Carving foam is VERY messy. So is plaster work. YOU are responsible for YOUR area. No one will be allowed to sit in alternative seats for this project. If someone irresponsible sits near you… you may become responsible for their mess in your space.

3. After carving the foam, you'll plaster it. After it dries, you can begin to paint and add materials like feathers or other objects to the mask. You may want to bring some craft items from home if you do not have them here.

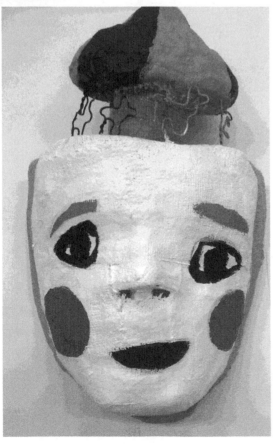 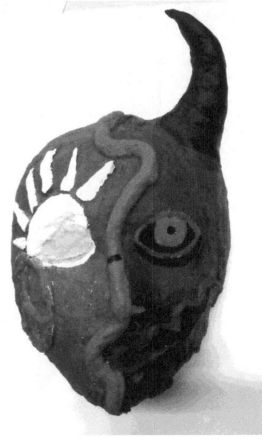

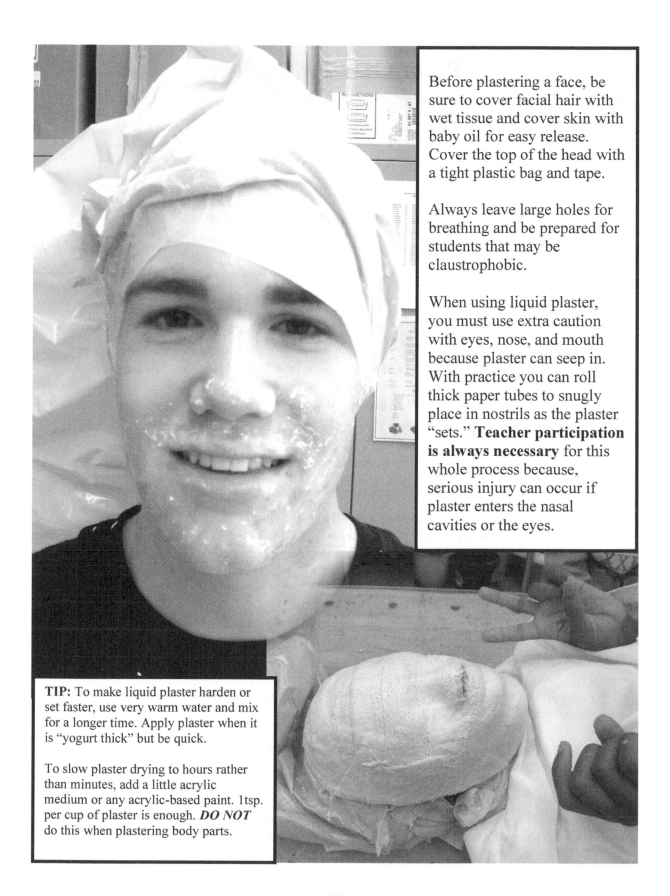

Before plastering a face, be sure to cover facial hair with wet tissue and cover skin with baby oil for easy release. Cover the top of the head with a tight plastic bag and tape.

Always leave large holes for breathing and be prepared for students that may be claustrophobic.

When using liquid plaster, you must use extra caution with eyes, nose, and mouth because plaster can seep in. With practice you can roll thick paper tubes to snugly place in nostrils as the plaster "sets." **Teacher participation is always necessary** for this whole process because, serious injury can occur if plaster enters the nasal cavities or the eyes.

TIP: To make liquid plaster harden or set faster, use very warm water and mix for a longer time. Apply plaster when it is "yogurt thick" but be quick.

To slow plaster drying to hours rather than minutes, add a little acrylic medium or any acrylic-based paint. 1tsp. per cup of plaster is enough. *DO NOT* do this when plastering body parts.

Point Of View Project

PART 1: List 5 to 8 friends and describe them in 3 or 4 statements or words

1. _____ : _____

2. _____ : _____

3. _____ : _____

4. _____ : _____

5. _____ : _____

6. _____ : _____

7. _____ : _____

8. _____ : _____

PART 2: Choose wooden forms to represent your friends. You may combine forms to create a new single form. Pick a large piece for a base and put your name on it. Glue all pieces to that one board. Use information from your packet about the emotional values of shapes. (Aggressive people with sharp forms, playful people with rounded forms…) Most people will need to be represented by a few forms glued together to make one form for that person.

PART 3: Complete 5 drawings on paper based on your structure. Fill the page with your drawings. *The teacher will demonstrate each method of drawing.*

1. Do a drawing as if you were a bug entering a new landscape. Things should tower over you. Some shapes may even go off the paper when you draw them… That's a good thing. This should be done as a contour drawing (An Outline). Color the whole image with only 2 primary colors and their analogous colors in-between those primaries. (Blue, turquoise, green, dark green, yellow). Shade by intensifying the colors you already are using by pressing harder.

2. A Blind Drawing: Look at the structure as you draw, but not at your hands. Pay careful attention to edges. Color the whole image with only two complementary colors, one for the object and the other for the shadows. Vary color intensity for a 3-D look to forms.

3. Negative Space Drawing: Draw what you see of the base without drawing the forms. Color monochromatically.

4. Gesture Drawing: Using loose sweeping lines to represent the structural form. Your teacher will demonstrate this. Color highlights with warm colors, shade with cool colors. Intensify colors by pressing harder or softer.

5. Realistic Drawing: Do this of the structure first in pencil as an outline, then marker over these lines. Use crosshatching or stippling to add shading. See sample under "crosshatching" in this workbook.

Who Am I?

Create a list of what people assume about you, and another list of what you know about yourself. Often outward perceptions are different from the reality. For example, people may know you like art, but may not know you traveled internationally, OR people may not know you have a special talent in some area. You may use visual codes to hide information you do not really want to share with others.

Note things that are similar with a "+" and differences with an "X".

<u>What others think they know about you</u> / <u>What you know about yourself</u>

1. _____ 1. _____

2. _____ 2. _____

3. _____ 3. _____

4. _____ 4. _____

5. _____ 5. _____

6. _____ 6. _____

7. _____ 7. _____

8. _____ 8. _____

9. _____ 9. _____

10. _____ 10. _____

11. _____ 11. _____

12. _____ 12. _____

Consider a two-sided project. Do a collage or drawing on one side about what people know about you and the other side revealing what they do not know. You could also do this with a box or mask, decorating differing parts inside and outside based on your lists.

Memorial Project

We will be creating an artwork based on someone special to you who is *no longer with us*. If you have not lost someone in your life, please pick someone you admire who is not living.

For privacy, if you prefer, you may use the person's initials to write below. Their name is: _____

Write about your most vivid memory of this person.

What about him or her has changed your life?

If you could tell people only one thing about this person, what would you say?

Please write 5 positive words describing the person.

Did he or she have any shortcomings, negative traits? Mention 1 or 2 of them.

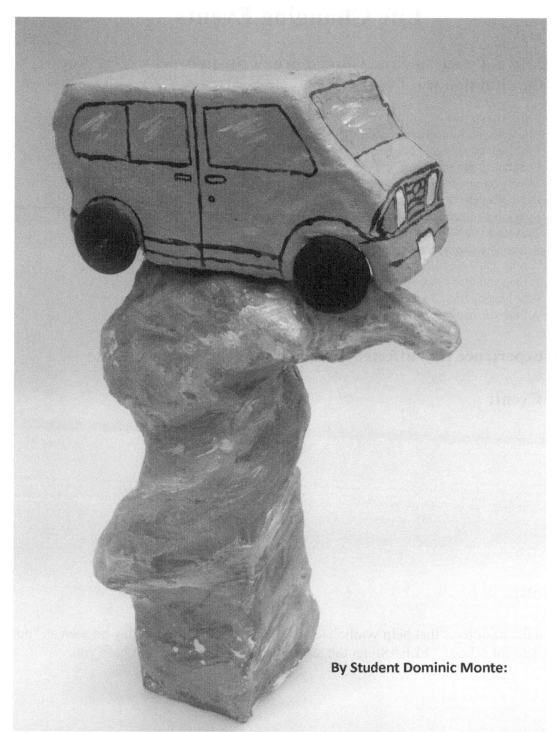

By Student Dominic Monte:

This memorial is about the student's grandfather and their long road trips to the ocean. This is their van riding a wave, symbolizing the fun of the experience.

Life Changing Events

IF you do not want to write yours down, write in code so YOU know what the situation was.

First driver's test
The time you won an award
First time you caught your parents lying
First time you went to a funeral
When you succeeded while everyone thought you wouldn't
Birth of a new family member
First job, or interview, or first firing
First time you were tempted to do something wrong
A time you saved someone's life, or someone saved yours
A time you were betrayed
A time you found money, or got your first paycheck
First hunting trip
A time you had to move to a new home or school

ANY experience that affected your life, for good or bad.

Your Event:

Symbols:

Create a list of objects that help symbolize the event. If your symbol may be seen as "not appropriate for school," PLEASE let the teacher know first for ideas to help you.

Symbolic Name

Objective: You will write your first or last name to show the things that are important to you, or things that you like. Your name should be 6 letters or more. The use of an initial after the first name might be necessary for a short name.

Helpful hints: DO NOT try to make an "A" an "A-Word" like <u>a</u>pple. Look at the shape of an "A" and see what it might look like? A slice of pie, pizza, tortilla chip, Doritos? Remember also an "A" can be written in many ways… even a triangle looks like an "A."

It always looks better if the letter is made from one object and not a bunch lined up to make the letter. Consider a bite in a cookie to look like a "C." It is okay to mix capital and small letters.

Start with the EASY letters like "O" or "A" and do the more difficult letters later. Try WRITING out the difficult letters in all the ways they can be seen. Capital, small case, script… seeing them in front of you makes a BIG difference. It's okay to ask a friend for suggestions, but you need to do all your own work.

THE LAY OUT

Use a half sheet of drawing paper cut lengthwise. Use a ruler on the top and bottom edges to make guidelines. Make the letters touch the top and bottom lines. This counts toward the neatness and completeness portion of the grade.

Draw in pencil first, LIGHTLY. Then re-draw the letters in pen. Erase out the pencil and color in very neatly with parallel strokes no wider than your thumb. Be sure to add details like highlights and shadows. Mix colors so it has a professional look. Single colors look "kindergarten-ish."

Alphabet Themes

LIST 5 themes for yourself and 3 themes of those close to you (Mom, Dad…)
BROAD themes are better than focused ones. You will have more choices.
For instance, choosing *Field Hockey* limits the amount of imagery you can use, but if your theme was *Sports* then you would have tons of other stuff to incorporate.

— Instead of Clothes, choose fashion (Then you can include Fashion Logos)
— Instead of Vegetables, choose Foods
— Instead of Rock and Roll, choose Music

There are 3 levels of difficulty to this project.

Level 1: A Single object repeated to create a whole alphabet, like the balloons below. If done very well can get a high potential grade of a low "A."

Level 2: A single concept with 30% to 60% related original ideas thrown in, like a theme of Plants. If done very well can get a high potential grade of a mid-range "A."

Level 3: Every letter is a different image within the theme. This is the most difficult and potentially can get the highest grade of 100%. (Here is a Logo Alphabet)

*****The Letters do not have to coordinate with the meaning. "A" does not have to be "APPLE" the symbol just has to be an "A" SHAPE.*****

Holiday Themed Alphabet Sample

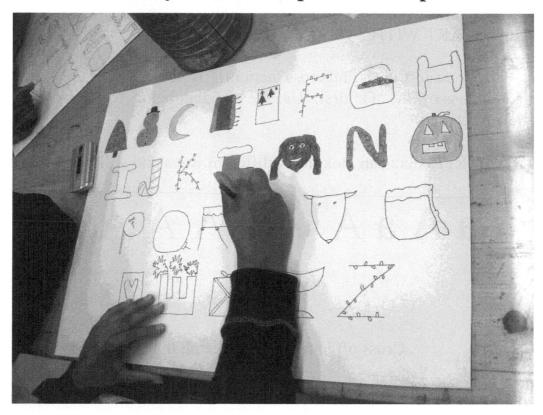

Note how each letter is different but still follows this student's theme of holidays. This is the highest level of achievement for this project.

By choosing a theme students can even make sculptural words to express their meaning.

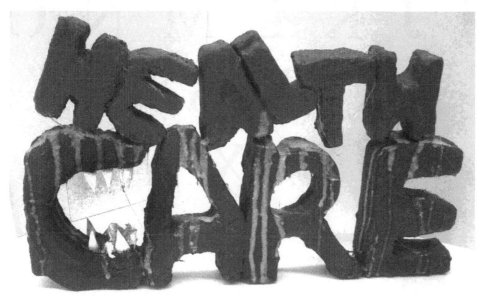

Helpful Hints

DO NOT START WITH "A"

Start with the easiest ideas and cross them off. If you chose SPORTS, make a ball and cross off the "O" first! Use the alphabet below to cross off what you have sketched.

REMEMBER! Letters can look many different ways and still be that letter.

A a A a A A a A A A A a

Cross off letters as you sketch them.

A B C D E F G H

I J K L M N O

P Q R S T U

V W X Y Z

Alphabet Sketch Page

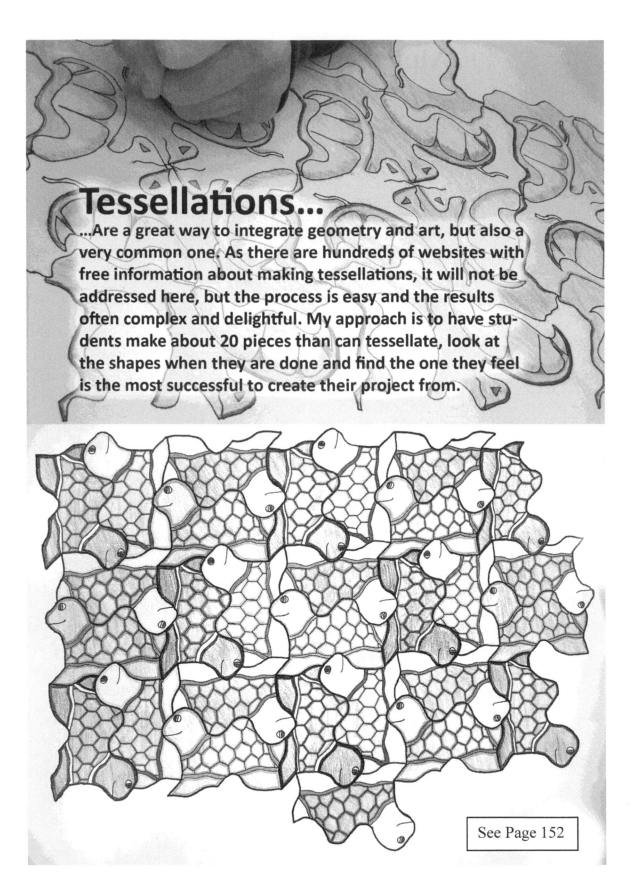

Tessellations...

...Are a great way to integrate geometry and art, but also a very common one. As there are hundreds of websites with free information about making tessellations, it will not be addressed here, but the process is easy and the results often complex and delightful. My approach is to have students make about 20 pieces than can tessellate, look at the shapes when they are done and find the one they feel is the most successful to create their project from.

See Page 152

44

Treasure Maps

Create a treasure map of an imaginary island. The island can take on the contour of an object, but break it into small pieces so it is not too obvious. Include the following: Detailed border, rose compass, longitude, latitude, 5 land feature symbols, key for symbols, 2 landmarks, 2 water symbols in the water, 1 sea monster, and 1 ship. Maps can be aged by wrinkling and soaking in coffee. Include geology & cartography elements.

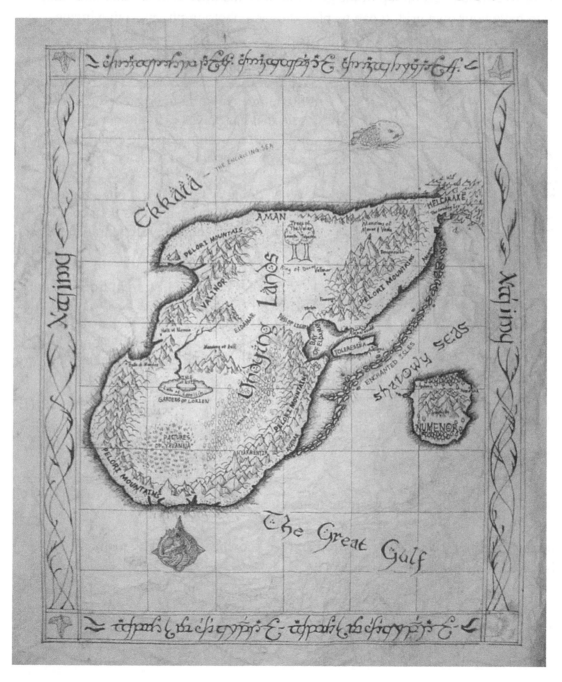

Grids

Grids can be a great way to transform a design, enlarge or reduce a drawing. They are often used to make murals.

The following pages have 3 grids of different scale. You can place a piece of plastic, acetate, or overhead sheet on top of the grid and trace the lines using a ruler and sharpie marker to have your own grid. It can be placed over a photograph, magazine image, etc, and transferred to a similar grid on another paper.

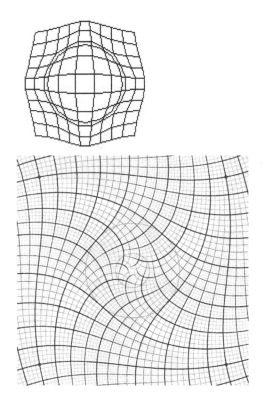

Sometimes it is fun to create a "*warped*" grid that has waves in it and curves and transfer the design into it to create a surrealistic or altered transfer.

When doing a warped grid, put a regular grid on top of an image, and then create a warped grid the image will be transferred to.

With the warped grid, straight lines are not necessary. It is sometimes best to make the outside border and divide that shape in half, and each subsequent division in half again until the grid has the number of divisions you feel will work. This can be done by hand with visual estimates.

When both are complete, transfer the design one square at a time.

Take your time and go square-by-square to transfer your design.

The regular gridding technique is very old and we know it was used by many Renaissance artists like Leonardo da Vinci.

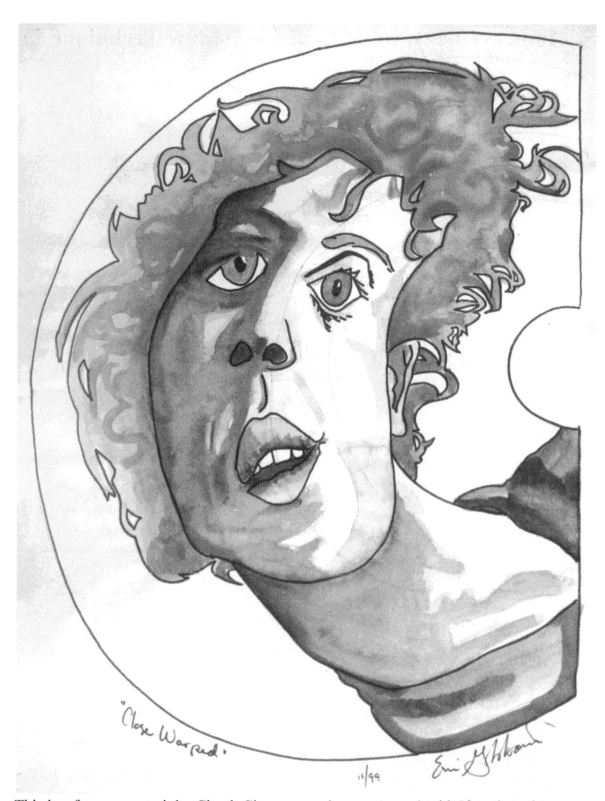

"Close Warped."

11/99

This is a famous portrait by Chuck Close, re-made on a warped grid. If students have access to Photoshop, they can alter pictures there and draw based on the printout.

Improvements with Regular Gridding Technique

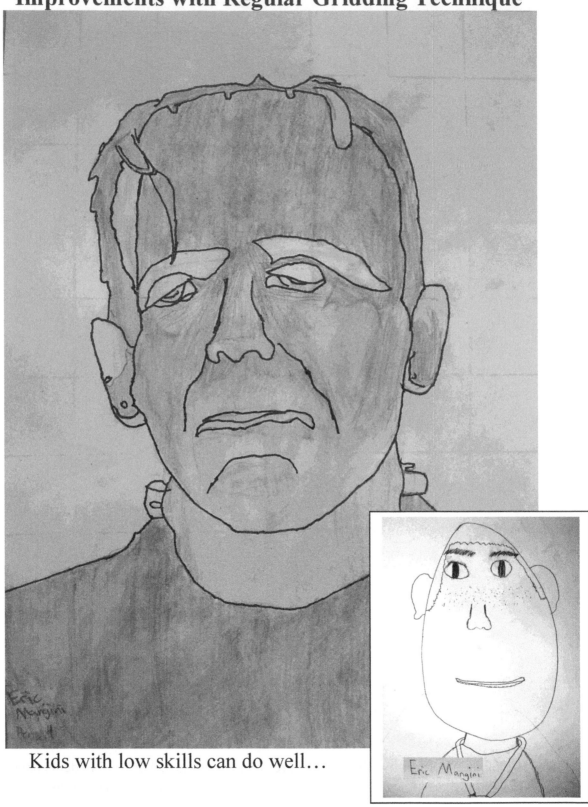

Kids with low skills can do well…

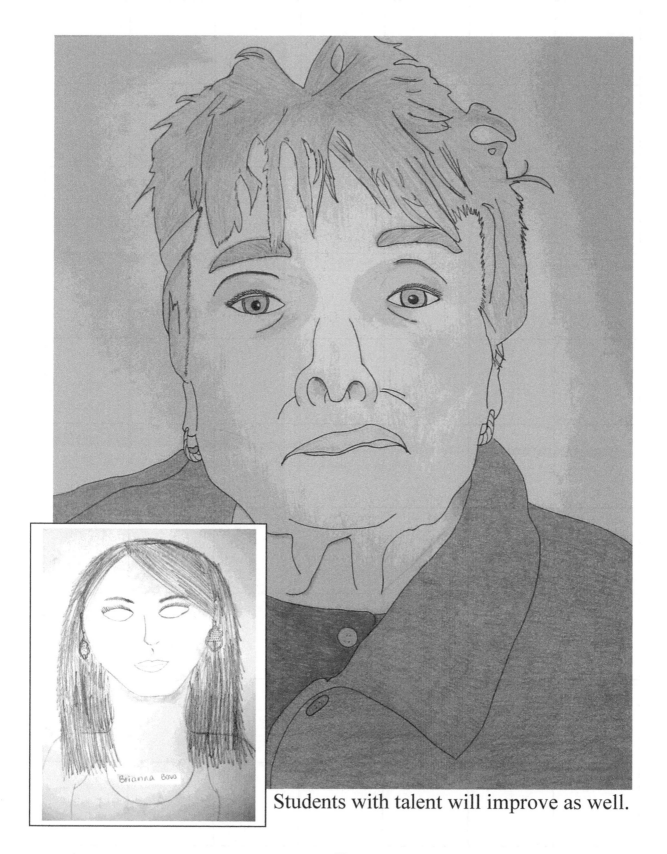

Students with talent will improve as well.

Art and MATH?!? *(You do not have to do all of these in one day, try one per week)*

If you want to enlarge a drawing, make a painting look 3-D, or be sure you are paid for your artwork correctly, you must have some basic math and geometry skills.

1. Let's say you wanted to sell your last art project and you want $100.00. You should probably sell artwork through a gallery. A gallery will take a percentage of the price the artwork sells for to help pay their employees, bills, rent, etc. Many galleries will take a 40% commission, leaving you how much? _____%. If you want $100 and the gallery will take 40% of the price, how much will the price be on the artwork to customers? (Use the space below to figure it out.)

2. In every state, you need to pay sales tax on a sale, but this is added on after the purchase. What is the sales tax in your state? _____ % . So the tax on the art sale in #1 is $_____
Show work here:

3. How much will the artwork from #1 be when you add sales tax from #2 to the final
 retail price? $_____ Show work below:

4. Most New York galleries will take a 50% commission. How much will their retail price be for the same work of art from question #1? _____ Show work below:

5. There are some grids in this workbook. How can you count the number of squares without counting each and every square? _____

6. The three grids in this book have how many squares? A _____, B_____, C_____ .
Show work here:

7. If you have a drawing that is 10 x 15 inches, and you frame it with a molding that is 3 inches wide, how large will the whole piece be? _____ x _____ inches.
Show work here:

8. Frame molding comes in long pieces, how long should the molding be to make the frame in #7 above?
 — It should be _____ inches long, total, or _____ feet and _____ inches.
 — Show your work here:

9. You have a present to wrap; the box is a cube with 6 inches on each side. How many square inches of wrapping do you need to cover the whole box without wasting any paper?
Show work here:

10. If you need precise measurements, why should you never measure from the end of a ruler?

11. Let's assume your class is going to paint a mural on one long wall in the hallway, and it will be so large it will take up the whole wall. On average, 1 gallon of paint will cover 350 square feet. How many gallons of paint do you need to buy? _____ gallons.
Show work here:

12. A gallon of paint may cost $15.00 each. From #2 use the tax rate of your state, and figure out how much the price will be for 1 gallon with tax? $_____.
Show work here:

13. Combining information from questions #11 and #12, how much money does your class have to raise to buy all the paint for your mural? $_____
Show work here:

14. Look back at question #1. If you did the math right, you will have earned $100.00 for the sale of your artwork. Does this mean you have a profit of $100.00? YES _____ / NO _____
— Explain why you said yes or no:

15. If your art room was an art gallery and the monthly rent is based on the square footage of the room, and the landlord charged $5 per square foot, how much is it to rent the room?

How wide and long is the room? _____ x _____ feet. Square footage of room _____ feet2
Show work here:

16. From question #15, you know the monthly rent for your art space. From #1, you know how much the retail price would be. What percentage does the gallery in #1 keep? _____% If

every painting sells at the same price as question #1, how many paintings of yours does the gallery need to sell to just pay its rent? _____
Show work here:

17. If it takes 30 seconds for each student to wash his brush in a sink, (one at a time) how many minutes need to be allowed for clean-up in the classroom? _____ minutes.
Show work here:

18. Mix equal amounts of black and white paint together. (Measure to be sure) When you mix black and white paint in equal parts, the gray you get is NOT a medium gray, but looks dark. This means a 1 to 1 ratio (1:1) is not producing a medium gray, WHY?:

19. What ratio of black and white paint makes a good, medium gray? (A scale might help)

← This is a medium gray

20. If you wanted 1 gallon of gray paint, what percentages of black and white do you need?

_____% white and _____% black.
Show work here:

Some answers are near the last page of the Teacher's Edition.

Art and Economics

What is the economy? _____

Though a career in art can be both creative and rewarding, some fields are more susceptible to the economy than others. Careers like teaching are often more stable than working in an advertising and design company. Schools need teachers, there will always be children, but when the economy gets bad, or the flow of money is less, companies spend less on things like advertising. Employees have less money to spend on things like art, going to museums, seeing movies, or even art therapy.

Even an art teacher can lose his or her job if a school feels that art just is not as important as other subjects and school budgets are being tightened.

Art is often seen of as a luxury, so often the first financial hardships are felt by art galleries and the artists they represent. From 2007 through 2011, many galleries all over the world closed after being open for many generations. This was a result of the financial problems not only in the USA but all over the world.

Your teacher can show you a chart of the Dow Jones Industrial Average by going to Google → news → business and clicking on the Dow Jones link under the financial chart there.

In general, when this number rises, the economy is doing better than when it goes down. Daily ups and downs mean very little and can be changed by daily political events, but a month to month look at the Dow Jones Industrial Average can indicate if the economy is getting better or worse.

If unemployment is low and the economy is high, people are more likely to buy luxuries like jewelry, cars, homes or art.

In the last 30 days has the DOW gone up or down? _____

In the last year has the DOW gone up or down? _____

What is the current unemployment rate in your state and in the USA?

State: ____ : _____ , USA: _____ (Less than 6% is a sign of healthy employment)

Is the economy good now for art? _____ Why do you think so? _____

Would you guess things are getting better or worse? (And why?)_____

Perspective

(1 Point, 2 Point, and 3 Point)

Vocabulary

— Perspective

— Horizon

— Vanishing Point

— Parallel

— Converging

— Vertical

— Eye Level

This is an example of 1 Point Perspective. Everything seems to be going to one point "A".

Your Name in 1 Point Perspective

1. Can you draw your name with block letters? Do it below.
2. Create a horizon and vanishing point.
3. Make all corners of your name go to that vanishing point.
4. DO NOT draw lines that overlap the letters of your name.

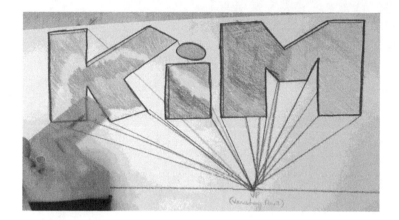

Use a ruler and draw along all the edges that go into the background. Where do they meet? What do we call this point? Is it the same for the image below?

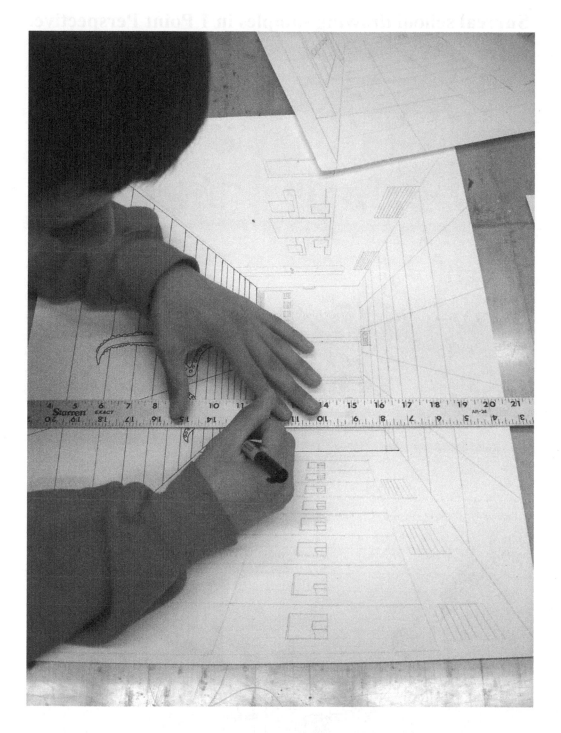

Students do a perspective drawing from observation of the school hallways, but finish by adding a surrealistic element. Here the student adds tentacles of some creature emerging from the floor.

Surreal school drawing samples in 1 Point Perspective.

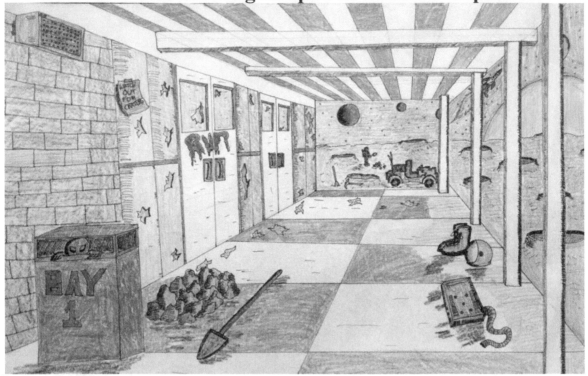

By Ryan Orlofsky

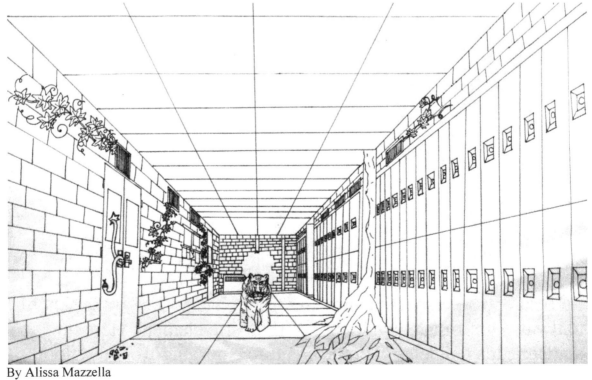

By Alissa Mazzella

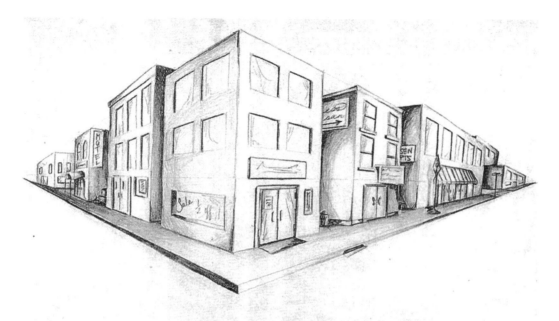

This is an example of 2 Point Perspective. See how both sides seem to converge to different points on the same horizon.

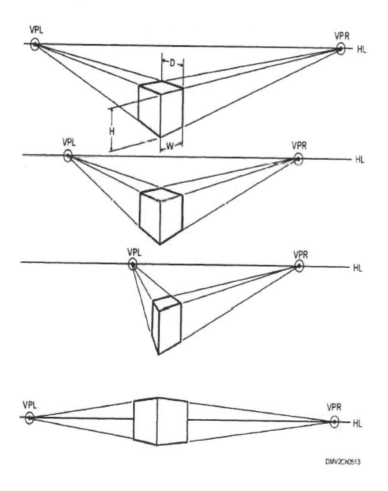

This is how 2 point perspective is used to draw boxes.
You may not be required to do a 2 point perspective drawing, but you need to know about it and explain the concept.

DMV2CH0513

THREE-POINT PERSPECTIVE

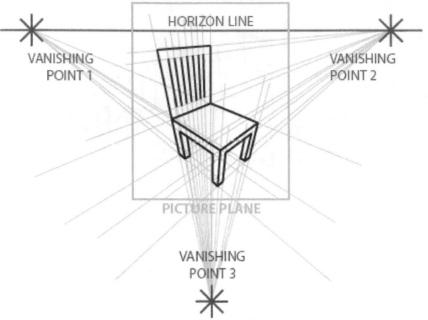

3 Point Perspective is shown above. It is NOT a requirement to do a project in 3 point perspective, but you do need to understand the concept.

Try to draw a cube below and make it look 3-D.

Drawing Boxes in 1 point perspective

1. Draw a horizontal line with a ruler, somewhere below. This is the *Horizon*. (It can cut through a box)
2. Draw a **dot** somewhere on the line.
3. Make the corners of the squares below connect to that **dot,** we'll call that the *Vanishing Point.*
4. Erase completely any lines that cut through a square.

Crosshatching

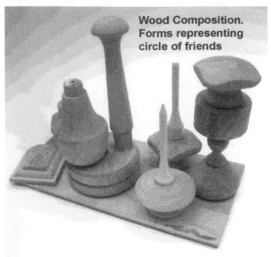

Wood Composition.
Forms representing
circle of friends

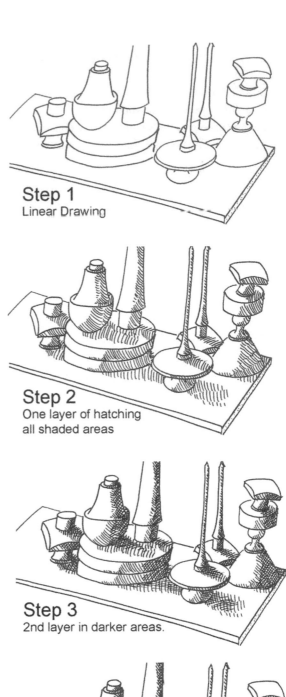

Step 1
Linear Drawing

Step 2
One layer of hatching
all shaded areas

Step 3
2nd layer in darker areas.

Step 3
3rd layer in darkest areas.

Repeated lines can create the illusion of shadow and form. The above image was done step by step to the right. This is the same technique used to create the faces you see on a dollar bill.

It can be done also with dots (Stippling) or any repeated line, even scribbles.

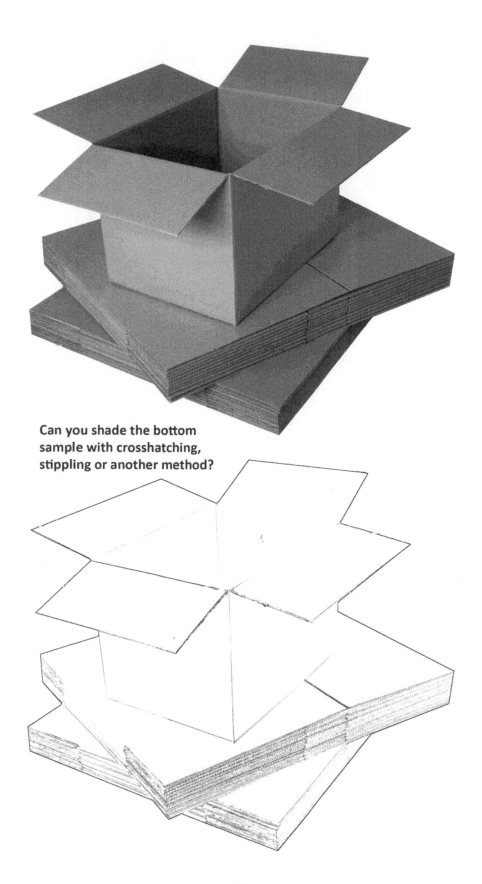

Can you shade the bottom sample with crosshatching, stippling or another method?

Coloring Spheres

This first example is monochromatic (variation of a single color, like black or blue…)

MONOCHROMATIC

Please color in the following 6 circles. See the sample so your circles look like shaded spheres too.

Primary colors
Secondary colors
Analogous colors
Complementary colors
Any color plus black and white
1 color, use pressure to show light and dark.

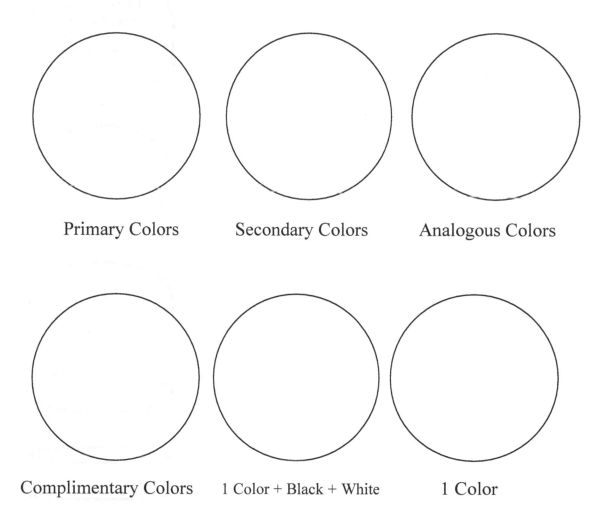

Primary Colors Secondary Colors Analogous Colors

Complimentary Colors 1 Color + Black + White 1 Color

4 Basic Forms

Cone Cube Sphere Cylinder

Try drawing the 4 forms here. Color and shade them.

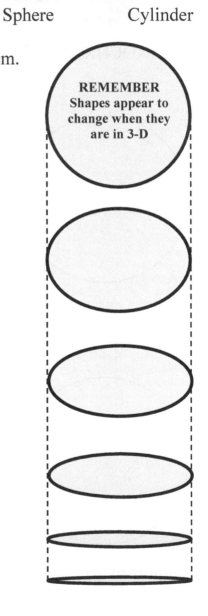

REMEMBER
Shapes appear to
change when they
are in 3-D

Face Proportions

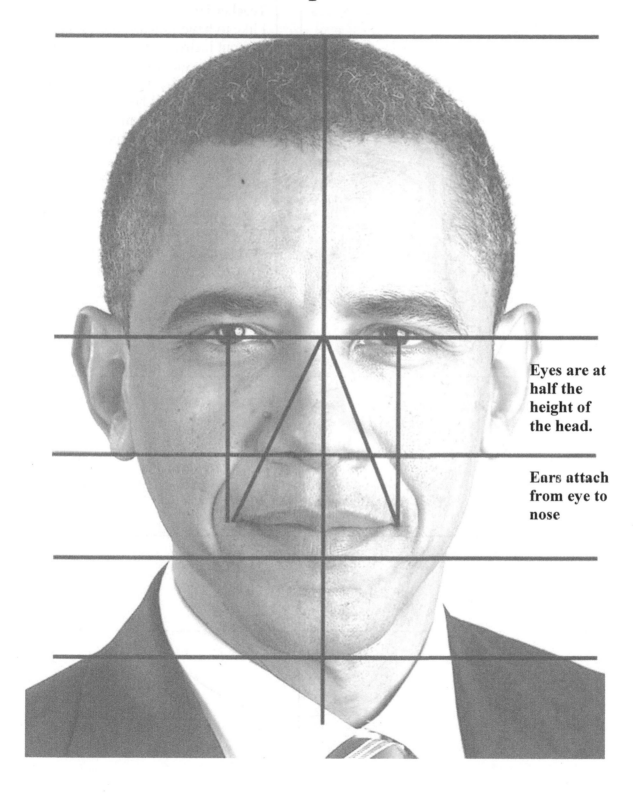

Eyes are at half the height of the head.

Ears attach from eye to nose

Face Map Proportions

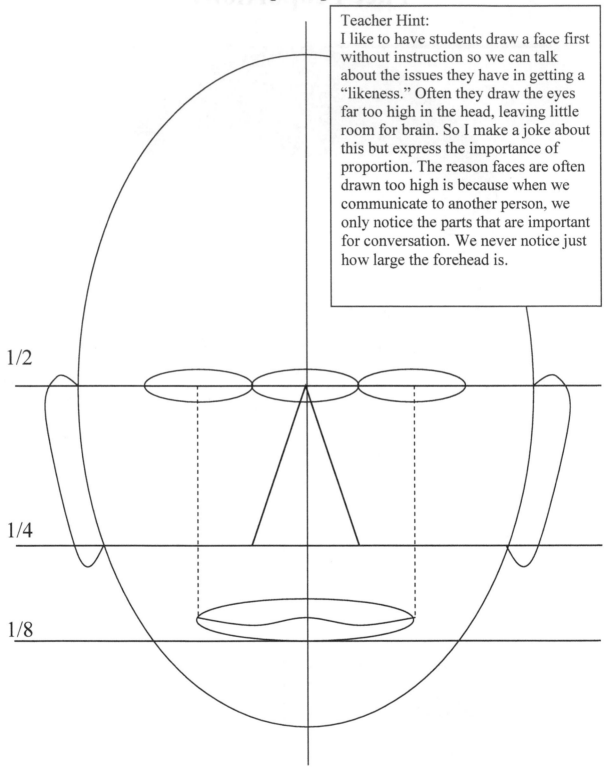

1/2

1/4

1/8

Teacher Hint:
I like to have students draw a face first without instruction so we can talk about the issues they have in getting a "likeness." Often they draw the eyes far too high in the head, leaving little room for brain. So I make a joke about this but express the importance of proportion. The reason faces are often drawn too high is because when we communicate to another person, we only notice the parts that are important for conversation. We never notice just how large the forehead is.

Plankton & Pollen

Look up and research other forms of plankton, bacteria, viruses, and pollen for more interesting forms in nature. You can make a reproduction in a variety of materials, or create a new one based on images you find. How about creating an Alien Pod?!?

Plankton above

Pollen to the right

Sculpture
Science Meets ART

In most cases diseases and illnesses are caused by a virus, parasite, abnormal cells, or infection. Name as many diseases or sicknesses that you can?

1. 6.

2. 7.

3. 8.

4. 9.

5. 10.

Choose one of the above illnesses. Look up what organism causes that illness, and what it looks like. Draw it below and add color too.

Your number _____ and its cause is _____

Diseases and Other Creepy Crawlies

Find some time to go to the library or computer lab and look up viruses, bacteria and cancer cells. They can either print or sketch what they find. Below are Phages infecting a bacteria cell.

Above: *Mycobacteriophages*

TEACHER HINT:
I require my students to be able to find the proper scientific name for their cell, which later becomes the name of their project.

Students then re-create their cell with plaster over an aluminum foil base adding in straws, wire, dowels or pipe-cleaners to make it look as similar as possible.

When that is complete I ask them to finish their project with patterns, glitter, yarn, and artistic embellishments so that their work is not just clinical, but a work of sculptural art.

Virus Project Samples

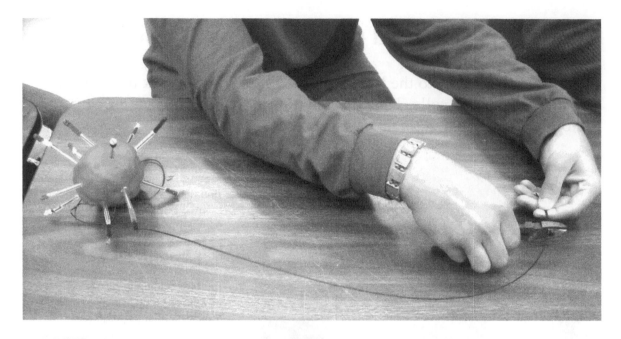

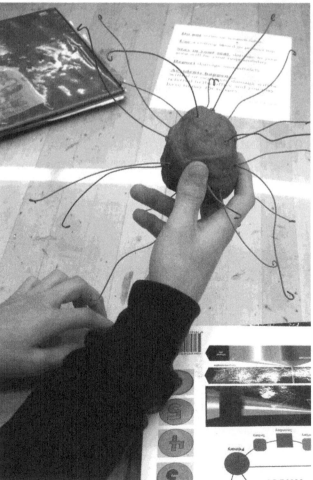

Students creating and embellishing their virus sculptures.

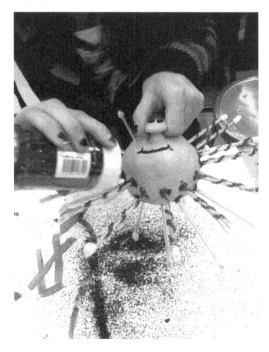

Self-Operating Napkin

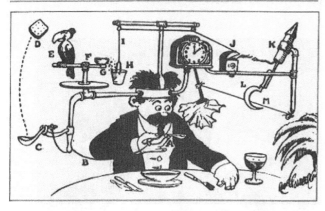

This is an example of a ***Rube Goldberg Machine.*** Mr. Rube Goldberg (1883-1970) was a Pulitzer Prize winning cartoonist, sculptor, and author. Rube decided after six months that engineering was not his calling.

Best known for his INVENTIONS, Rube's early years as an engineer influenced his most famous works. A Rube Goldberg contraption—an elaborate set of arms, wheels, gears, handles, cups, and rods, put in motion by balls, canary cages, pails, boots, bathtubs, paddles, and live animals—takes a simple task and makes it very complicated. He had solutions for "How To Get The Cotton Out Of An Aspirin Bottle," and imagined a "Self-Operating Napkin."

The video "The Way Things Go" is by 2 artists, Peter Fischli and David Weiss trying to make the largest and most complicated Rube Goldberg Machine possible. On this paper, try to list the order of the contraptions so you can document the chain reaction. The list below is started for you; see if you can complete it.

1 Trash-bag unwinds	11_____	21_____
2 Hits tire	12_____	22_____
3 Tire rolls to see-saw,	13_____	23_____
4 Hits another tire	14_____	24_____
5 Hits ladder	15_____	25_____
6 Hits table	16_____	26_____
7 Push over raft	17_____	27_____
8 _____	18_____	28_____
9 _____	19_____	29_____
10_____	20_____	30_____

Crystal Structures / Linear Forms

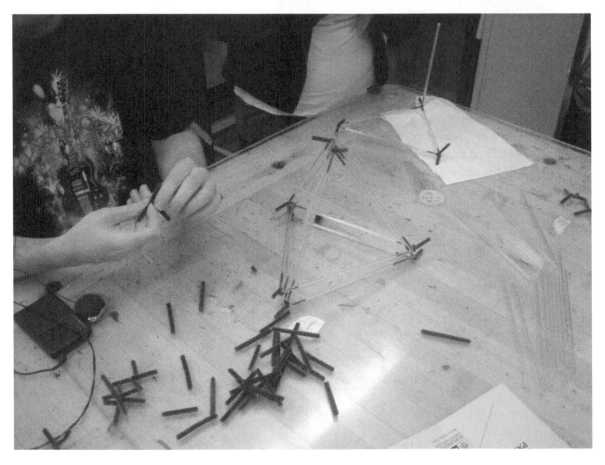

Students can make crystals, emulating geometric structures from research of the structures found in minerals from eNasco.com acrylic straws, 527 glue and pipe cleaners.

Mechanisms of Unknown Purpose

Students create a mechanism that looks like it could do something made out of old mechanical parts of TV's, computers, radios etc…

Safety is an issue; always use safety glasses when destroying stuff.

Inventing & Art

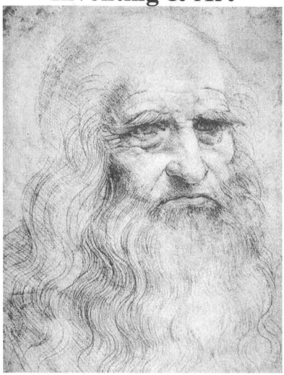

Leonardo da Vinci
April 15, 1452 – May 2, 1519

Leonardo is one of the most famous artists of all time. He was a part of a time we now call the Renaissance. The word renaissance means re-birth. In this sense it was the rebirth of Greek and Roman art but it was more than just that and extended into math and science. The term Renaissance Man, describes a person that can do many things well, and this was a great description of Leonardo. He was well educated about science, geometry, art, and geography.

His most famous work is the Mona Lisa, a painting that is considered the most valuable work of art in the world. It is in the Louvre (Loov) museum of Paris, and is considered the most valuable work of art in the world.

One of the amazing things about da Vinci is that he would sketch ideas for inventions. Some were for weapons of war so his country could defend themselves from attack. His tank design is below.

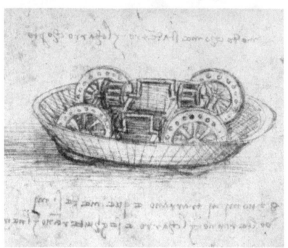

He even invented flying machines hundreds of years before they were possible. Here is a design like a helicopter.

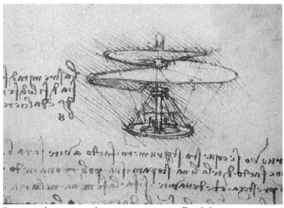

Inventing can be a very profitable venture and a highly risky one that can cost a lot of money for patents, prototypes, production, manufacturing, and marketing. But look in your pockets or around your house and you will see hundreds of inventions.

Quirky.com Invention Lesson:

Quirky is a collaborative invention website with a model that lends itself to collaborative classroom learning. It is worth exploring the site a bit before beginning this lesson.

Essentially, one uploads an idea, the Quirky community comments on it with suggestions for improvements, votes on it, and if chosen by the Quirky company, it is made and distributed across the USA and even internationally. The person that uploaded the idea gets a significant portion of the profits, as does everyone who actively participated in the idea with suggestions, improvements, votes, designs, etc.

This idea can be done on a classroom scale where students create ideas, vote on them, make suggestions, allowing for improvements, and a final vote. The Quirky company is interested in reaching out to classrooms and supporting education. They can provide free codes for ideas to be uploaded to their system under parental supervision and a parent's account. It is strongly advisable that submissions include some kind of statement that the idea was submitted by a child with parental supervision so the people on Quirky are more understanding in their comments.

I have done this and Quirky usually supplied me with a code for up to 20 students to use. I do this project with 150 students, so the top 20 ideas, as voted on by their classmates, get an envelope with a code to upload their ideas at home.

It is helpful to review top votes and do a simple Google search to see if the top ideas are relatively original. If not, I label them as "Available" and that student is ineligible for a winning code. Quirky is only interested in original ideas. To avoid this problem, the project might have a research component where students look up their ideas and see if they are already broadly available.

As you can see, this lesson integrates research skills, composition, drawing, problem solving, some math, and possibly some science skills. It is always a popular unit and an opportunity for your Board of Education, your supervisor, and maybe even your local press to see what your department is doing.

Quirky Inventing

www.Quirky.com

Quirky is an open format invention website found at Quirky.com, where people comment, vote, suggest, improve, and essentially your product is brought to market via a community. This lesson emulates quirky in our classroom. Your teacher may contact the company and ask for free codes for students to submit ideas with their parent's permission. questions@quirky.com

If your idea is chosen to be made by Quirky, it may be in stores all across the nation and you will earn a percentage of every sale.

Consider answers to the following:
What problem does your idea solve?
How does it solve it?
What makes it unique?
Does it already exist in some form?
Who else makes something similar?

Your 140-character product description is your big chance to attract people to your idea page. Be as clear and specific as possible, and try to avoid naming your product correct grammar doesn't hurt either.

DO: Say what it does in a nutshell
DO: Be Clear
DO: Spell well
DO: Use space-savers like "&" for "and."
DO: It's okay not to use all 140 title spaces
DO: Re-read it as if seeing it for the first time
Assume your reader knows NOTHING
DO NOT: Make people guess what it is with a teaser, people will often pass up coy headlines
DO NOT: Reply unkindly to comments, even if they are unkind first.

Is your idea an invention or not?

Inventions: New Ideas – Rare but valuable
Innovations: Make inventions work better
Design: Makes an idea look better.
All three are fine for Quirky.

Where can you get ideas?

- Talk to your friends about chores they hate, how can you make it easier or more fun?
- Think of things you do that could be made easier to accomplish?
- Think of your hobbies, what would make them more fun?
- How can you make an item of clothing functional or multi-purpose?
- What could you make that would keep you more organized?
- How can you take an item everyone around you seems to have and make it better?
- Consider ideas for the kitchen, pets, garden, fitness, organization, or items that would be more decorative than they are now.

10 Bad Submissions or ones that are overdone.

1. Things that can distract you while driving.
2. GPS devices for lost things or children.
3. Cord Organizers for phones or computers.
4. Food or medicinal ideas.
5. New cases for i-Pads or phones.
6. Temperature indicators for cups, bottles…
7. Drink ID tags.
8. Solar powered hair dryer, or teakettle.
9. Remote controls for things you can do easily.
10. Toothbrush/toothpaste combinations

Invention Submission

140 Character Overall Description: (Count Spaces) *don't include a title/name unless it helps describe what it does.*

Circle the category would this best fit into:

Kitchen	Toys	Home Décor	Lawn & Garden	Electronics
Organization	Fitness	Accessories	Pets	Other

Describe the problem you want to solve:

Describe your solution and what makes it unique:

What are some key features of your product?

Name 3 products that compete with your product.

1. _____

2. _____

3. _____

Your Idea Sketch:

(Consider scale, materials, label parts, make your drawing clear. Use a ruler)

Wire Tree: Using stovepipe wire or copper, students take 50 to 100 thin strands at about 1 ft in length and twist the wires to make a tree, splitting bunches and twisting roots and branches. Foil, craft jewels, or other leaf-like objects can be added as leaves. Couple this project with Bonsai Trees for multi-cultural approach and expressive composition of natural elements.

— Cut wires are sharp. Blunting the ends with a curl can be helpful.

— Beads or other craft items can be used instead of foil leaves.

— Kitchen aluminum foil is generally too thin. You may need to use *embossing* foil.

— The above example uses a wooden base with a small sharpened dowel hammered into the bundle of wire at the base to tighten it and keep the wire from falling out.

— Alternative to base: Twist wire from both ends to create roots AND branches. These trees can be added to an object to create a larger symbol. For example, if the roots were wrapped around a book it might make a statement about recycling. If wrapped around a skull, maybe about death. Always try to couple projects with life experiences.

Cut wire to 2 ft. curl sharp end. - Put in a base or create roots - Cut leaves from foil or stamp them
Add sharp dowel to tighten - Emboss veins with pointed stick

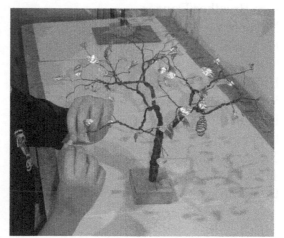

Leaves can be stamped - Separate and twist branches - Assemble with pliers. Pinch leaves on to fasten.

Wire Circus

The wire circus is based on of the work of Alexander Calder. He is an American artist famous for working with wire and metals to create different types of sculpture. He is most famous for his invention of the mobile. **(Provide internet examples, book images, or video)**

Today, however, you will be joining the circus. You are going to choose one circus act/job and create a wire sculpture of it.

Trapeze Artist
Lion/Tiger
Monkey
Elephant
Elephant Trainer
Ring Master
Unicycle Rider
Seesaw Acrobats
Contortionist
Clown
Strong Man
Bearded Lady
Lion Tamer
Peanut/Popcorn Vendor
Drink Vendor
Sea Lion Act
Acrobat
Tightrope Walker
Fire Breather/Dancer
Magician
Human Cannon Ball
Horses
Horse Rider/Tamer
Sword Swallower
Dog and Pony Show
Barker
Ticket Window
Trick Motor Cycle
Come up with your own act: _____

Collage Projects with Meaning

Choose to go one of two routes with the project.

#1. Self Expression: Choosing images and topics of self-interest. Incorporating magazine images and even snapshots, images from the web etc… to create a statement about yourself.

#2. Political or Point-of-View Message: Choosing images that have a message by their combination or juxtaposition. Incorporating magazine images and even snapshots, images from the web, etc… To create a statement about your point of view on a topic that is important to YOU.

Expectation: These collage projects can be "loose and chunky" like the work of Robert Rauschenberg (provide sample) or they can be comical like the work of Romare Bearden (provide sample), or even cut and pasted in such a way that it look realistic or surrealistic, like the work of Salvador Dali or Rene Magritte.

Even if "loose and chunky," these projects should be done with good technique. Edges must be pasted well and have a flat, completed look.

Outcomes:

Though the collage can be a finished project, here are some alternative further uses of images:

— The image can be scanned and printed on transparency plastic, then use an overhead projector to transfer the lines to a large canvas, OR use a grid to enlarge the original collage.

— They can be simply photocopied and colored with expressive colors.

My Cultural Background

Create a project based on information on your cultural background by creating a background pattern of repeated pattern of cultural objects and a foreground animal representing that artist's personality. Many people have different cultural backgrounds.

Cultural Background #1 (Country of origin)	Cultural Background #2 (Country of origin)	Cultural Background #3 (Country of origin)
Cultural Objects *Flowers, crafts, trees, symbols*	Cultural Objects *Flowers, crafts, trees, symbols*	Cultural Objects *Flowers, crafts, trees, symbols*
Animals from that country	Animals from that country	Animals from that country

Pick an animal and symbol for your project to represent yourself:

Create a background pattern of objects based on information above found at the library or on the internet. Then cut and paste an animal symbol for yourself on top. Any media will work for this; try colored pencil, marker, or painted paper.

Pen Project

Creating a dip pen using natural materials
Start with a stick base which will be carved with an
X-Acto knife. **(See Razor Safety)**

The concept or story is that the pen should look like it
has some mystical quality about it beyond the simple
fact it is a pen. What would the pen of a Medicine Man
look like if it was used to write spells for victory in war,
or to write a love spell, or one for murder, healing,
knowledge, peace… Be imaginative.

Warning: KNIVES ARE SHARP AND
DANGEROUS!
— Always cut away from you.
— Always have distance between you and your
classmates.
— Always cover the blade when not in use.

NEVER PLAY WITH THE KNIFE, THIS IS NOT A
JOKE!!!

A knife is considered a dangerous weapon. Should you
take one from this room, you could be prosecuted as
though you were carrying a weapon in school!

PROCEDURE

The bark may be completely or partially cut away so as
to leave a desired texture.

Carve the stick to have a pattern that enhances your
theme. Think of simple patterns you can carve in like
rope, criss-cross, X's, waves, or whatever you think
will work best.

The pen will be decorated with string, twine, raffia,
beads, wire, feathers, felt strips, or whatever you can
bring in. See teacher when you are ready to add the pen
tip. It can be glue and tied on.

Student holding his personalized dip pen.

My Name in Chinese

The origins of Chinese written language are based on pictures that have been simplified over the years. In this project we try to turn the symbols back into pictures that tell a bit about the artist.

Students can rewrite the characters so that the personality of the person shows through. If a student is an artist, the brushstrokes can be translated into art supplies laying in the same order, so we see both art supplies AND the writing that says their name in Chinese.

To find Chinese translations of "English" names, use Google to search the words "Chinese name English." It should be the first site listed.

As a cultural introduction, students can try to use bamboo brushes or round brushes to reproduce some Chinese characters easily found through a Google image search. To find names go here:

— chineseculture.about.com/library/name/blname.htm
— www.chinesenames.org
— www.chinese-tools.com/names
— chineseculture.about.com/library/name/family/blfn.htm

For example, the name "ERIC" can be written like this.

Take these characters and draw them in a way that you can see the things that interest "Eric."

For extra credit, can you find the meanings of the symbols in your name?

Students experiment with Chinese calligraphy, ink, and bamboo brushes before doing the name project.

Trompe L'Oeil – Illusions In Art

Trompe l'oeil is a French term literally meaning "*to deceives the eye.*" It dates back as far as 400 B.C. and was part of the rich culture of the Greek and Roman Empires. It is artwork that attempts to be so realistic that the viewer is fooled into thinking that actual three-dimensional objects are being displayed rather than a two-dimensional representation of those objects. In the mid-to-late 1800s, an artist named William Harnett revived *trompe l'oeil* still life easel painting in the United States. Traditionally, the preferred medium for this type of fine art has been oil painting, but it can be done in any media including pencils or paint.

Sun Samples

These are radial designs of the sun from many cultures, can you make one from your own cultural background? What is your cultural background? _____

Draw or write some symbols from your culture below:

TEACHERS:
It is helpful to have samples of different types of suns available for students to see.

Mr. Joan Miro, Surrealist Painter. 1893-1983

Take a sharpie pen and create a childlike sketch of a memory you have of some key moment in your life. It can be a happy or painful memory. All elements of that moment should be shown in the picture. Let figures and things be shown as simple shapes that can be colored in, you may even use a word or two, BUT NOT SENTENCES. Remember, stick figures are not shapes, you need shapes that can be colored in. Think of simple patterns that can represent elements from within that memory, the place, the surroundings.

This is supposed to be a memory image and does not have to be realistic in handling. Things may float, overlap, be combined or attached to each other to enhance connections, or even shattered into separate pieces.

Think of the emotions of the memory. If you were heart-broken, would a shattered broken image be best to describe it emotionally? If you are meeting someone you love for the first time, connectedness might be important in the drawing.

Joan Miro is known for his playful art. His symbolic images make a naive, childlike impression at first sight. In contrast to the image of his art, he was a solid, hard-working man who preferred to come to gallery exhibitions in dark business suits.

In the beginnings of his career he dabbled in different painting styles, like Fauvism and Cubism, that were fashionable at the turn of the century.

Paris - the Mecca of Arts
In 1920 Miro made the first of a series of trips to Paris. In 1921 he settled permanently in the French capital. He met Pablo Picasso and many of the other great painters and artists living in Paris the center of arts in the late nineteenth and first half of the twentieth century.

From 1924 on, Miro joined the circle of the Surrealist theorist Andre Breton. His painting style took a turn to Surrealism. His comrades were Andre Masson and Max Ernst. But he never integrated himself completely into this group dominated by Andre Breton. He remained an outsider.

By 1930 the artist had developed his own style. Miro's art is hard to describe. It is characterized by brilliant colors combined with simplified forms that remind of drawings made by children at the age of five. He liked to compare his visual arts to poetry. Later he moved to the USA and became very famous with many exhibitions in museums across the country.

In a letter to gallery owners he wrote: "What I will no longer accept is the mediocre life of a modest little gentleman." In 1956 Miro could finally move into the villa of his dreams. It was located in Palma de Majorca and built by the architect Josep Lluis Sert. The new home was built in an ultra-modern style typical for the avant-garde architecture of the fifties. In 1992 it was transformed into the Miro Museum open for the public.

Miro was a prolific print maker. He worked in etchings and lithographs. Miro is among those modern artists like Picasso or Chagall whose works were also published in large print editions targeted at a larger audience.

NUMBERS as a Theme

Create a painting, illustration or sculpture based on a number theme.
Work as a group or individually. Research and find more
About your chosen topic, or discover a new one!

2
Good and evil
Yin and Yang
Noah's Ark, 2 of each animal
Twins

3
Holy Trinity
Ages of man
Branches of government
Strikes
Jewels of Buddhism
Pure Ones of Taoism
Hear no evil, see no evil, speak no evil

4
Seasons
Beauties of China
Elements
Archangels in Islam
Four Horsemen of the Apocalypse
The four Gospels

5
Fingers
Books of Moses and Psalms
Basic pillars of Islam
Mayan Worlds
In India, mythological headless male warriors

6
Tastes
Foods placed on the Passover Seder Plate
Articles of belief of Islam.
Degrees of Separation
Cardinal directions: N. S. E. W, up, and down

7
Deadly sins
Virtues
Wonders of the world
Continents
Seas
Colors of the rainbow
Seven days of creation
Fires of hell and doors of Hell
Asian Lucky Gods

8
Days of Hanukkah
The number of Angels carrying the Throne of Allah
"The Immortals" Chinese demigods

9
Planets
Choirs of angels

10
The Commandments
Plagues
Lost Tribes
Branches of the tree of life
Canadian provinces

11
Soccer players
Cricket players
FootballpPlayers
Incarnations of Doctor Who
Guns in a military salute

12
Apostles
Cranial nerves
Olympians
Tribes of Israel
Days of Christmas
Months

13
Baker's Dozen
Attendees of the Last Supper
Witches in a coven
Colonies of the USA

SERVICE PROJECT - Survey

The art department will create a project based on the community and recognizing its needs. Students will complete this form to help identify a specific need that should be brought to our attention. Our focus will be on intolerance within the school and community.

This could be about special needs students and students using the word "Retarded" or some group you feel is misunderstood and subjected to undue disrespect, ignorance, and intolerance.

What local social group should we focus on? Why?_____

What do people not know about this group? _____

How does the intolerance hurt this group and hurt our community? _____

What can be done to bring attention to this issue? _____

(The next few pages are a sample service project the author used to inform
the community of bias language and bring awareness to bullying.)

TEACHER NOTE: *Service projects can take on MANY forms; this is one that was successful for us. You may wish to create your own survey for students to identify a "need" in your community and compile ideas on how to help or meet that need. One could do an auction, beautification project, donations of materials, etc.*

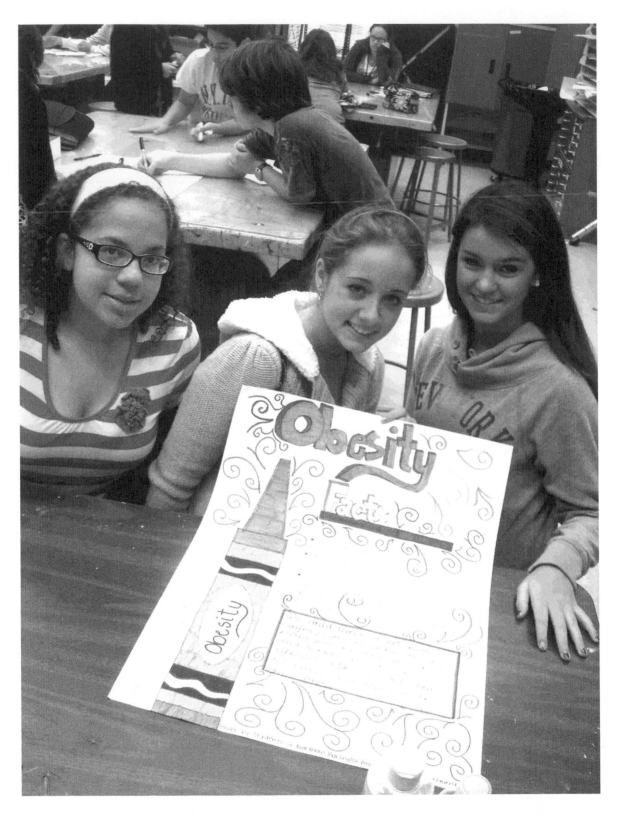

Student group with topic of obesity & bullying in school.

Design Agency

Team Name_____ Topic _____

Members _____ Period _____

Your task is to create a poster to make people aware of the intolerance some face in school and help educate our community through posters. Posters will need to have a professional look and follow the layout of the Autism Sample. Your group will need to do some research on your chosen group so that your facts are accurate. Completed posters will be presented to the design firm CEO (teacher) for assessment.
(Sample on next page)

Posters that meet all of the requirements will be laminated and placed throughout the building and later throughout the community.

Write your ideas below and present them to your manager (teacher) for approval. Passes for research to the library can be given if necessary.

Once research and design is complete, the group will complete a sketch before beginning a final poster.

AUTISM

Students with Autism are in our school and community. Words like "Retard" are hurtful, mean and intolerant.

FACTS:

—Autism is a neurological disorder characterized by impaired social interaction and communication.

—1 in every 150 children is diagnosed with autism.

—The cause is currently unknown but does have a genetic link.

We could learn a lot from crayons; some are sharp, some are pretty, some are dull, some have weird names, and all are different colors....but they all exist very nicely in the same box.

Poster by students of _____ School Art Department

SERVICE PROJECT PLAN

Team _____ Period _____

Topic _____

What does your team already know about this topic? What are facts you think you know?

What are some common misconceptions people have about the topic you have chosen?

Who on your team will be in charge of research?

Who will be in charge of design layout?

Who will be in charge of the written portion or the poster?

Who will oversee coloring to be sure everything is neat and professional-looking?

While your team member uses the pass below, please use the time to sketch a basic layout of your poster on small paper provided. This does not have to be neat, but should include all the required elements

Pass to _____ to research the topic of _____

Student: _____ Period: _____ From room _____

DATE: ____/____/____ **Signature** _____

Service Project: *FOLLOW-UP*

Name _____ Period _____

For each poster completed (up to 6) for the class, describe something you learned.

1. Poster theme: _____. I learned that... _____

2. Poster theme: _____. I learned that... _____

3. Poster theme: _____. I learned that... _____

4. Poster theme: _____. I learned that... _____

5. Poster theme: _____. I learned that... _____

6. Poster theme: _____. I learned that... _____

Where in the school was our poster placed? _____

Where in the community was our poster placed? _____

Social Issues Sculptures

Students decide for themselves an important social issue that affects themselves or their community and create a sculpture that symbolically illustrates the issue. Here we see "World Hunger" as food is within reach but still unreachable. Students also complete a statement about their topic to be placed with the sculpture to educate their audience.

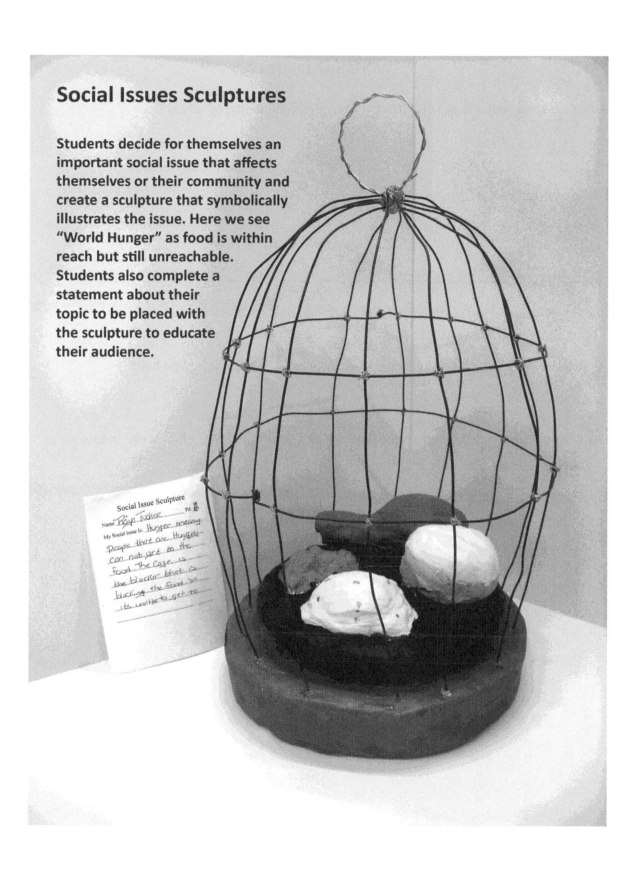

Social Issues

What are some social issues that affect your family, community, or school?

_____ _____

_____ _____

_____ _____

_____ _____

Which one do you think you know the most about or would like to explore more?

How might you symbolically represent that in a sculpture? Sketch or write below.

Sunset Silhouette

STEP 1: Starting from the bottom with YELLOW, create stripes of color that OVERLAP a little from one color to the next. (About 1 inch of overlap.)

STEP 2: Use the corner of a 6x folded piece of paper towel to blend the colors. be sure the transition from one color to the next is smooth and well blended.

Step 3: Add a horizon with a dark cool color, and fill in below it.

Step 4: Add a tree and 2 objects in black to your picture. Avoid putting things ON the horizon, they should be a bit below.

Dark Blue

Purple

Red

Orange

Yellow

Comic Book Ideas

Parody: Making fun of something, twisting what you know for a comic effect.

Superman → Stupidman
Terminator → Worminator
Godzilla → Tellitubbyzilla
Lord of The Rings → Lord of the Ring-Dings

What are a few movies you could make fun of?

_____ → _____

_____ → _____

_____ → _____

Try changing the title of something for a funny idea…

Teenage Mutant Ninja _____
Killer _____ from Outer Space
Attack of the Mutant _____

Your idea: _____

Try a new situation…

 Iron Man vs. Barney
 T-Rex comes to Sesame Street
 The President visits our school

Your idea: _____

There are millions of possibilities!

Do you cartoon already and have an original character???
This is a great chance to make THAT look professional.

ORIGINALITY COUNTS: Don't COPY known work.

For full credit, comic books need to include title, subtitle, dramatic action, logo, foreground, middle-ground, and background, items exiting the page, and overlap.

Title, subtitle, dramatic action, logo, foreground, middle-ground,
background, items exiting the page, and overlap.

Expressive Words	Compound Words
Love	Horseshoe
Hate	House fly
Flight	Dragonfly
Death	Football
Burial	Hotdog
Crazy	Rainbow
Strong	Waterfall
Sad	Groundhog
Depressed	Butterfly
Suicidal	Fireman
Hopeful	Firefighter
Grace	Dog food
Dirty	Toenail
Disgrace	Jellyfish
Shame	Starfish
Pride	Catfish…
Hero	Family tree
Sinful	Football…
Pius	Carpet
Travel	Honeybee
Risk	Hairnet
Anger	Hairspray
Contentment	Cheese grater
Gluttony	French fry
Lazy	French toast
Narcissism	Hummingbird
Turmoil	Pancake
Heaven	Shoehorn
Hell	Boxing ring
Regal	Earring
Eternal	
Complex	Other?
Simplicity	

JABBERWOCKY
Lewis Carroll
(from *Through the Looking-Glass*, 1872)

`Twas brillig, and the slithy toves
 Did gyre and gimble in the wabe;
All mimsy were the borogoves,
 And the mome raths outgrabe.

"Beware the Jabberwock, my son!
 The jaws that bite, the claws that catch!
Beware the Jubjub bird, and shun
 The frumious Bandersnatch!"

He took his vorpal sword in hand:
 Long time the manxome foe he sought --
So rested he by the Tumtum tree,
 And stood awhile in thought.

And, as in uffish thought he stood,
 The Jabberwock, with eyes of flame,
Came whiffling through the tulgey wood,
 And burbled as it came!

One, two! One, two! And through and through
 The vorpal blade went snicker-snack!
He left it dead, and with its head
 He went galumphing back.

"And, has thou slain the Jabberwock?
 Come to my arms, my beamish boy!
O frabjous day! Callooh! Callay!"
 He chortled in his joy.

`Twas brillig, and the slithy toves
 Did gyre and gimble in the wabe;
All mimsy were the borogoves,
 And the mome raths outgrabe.

Try and do a translation of each stanza,
Remember, often there is no correct
answer, but there is a story here…

Repeated from above, no translation
needed.

109

The above had plaster claws added to the canvas for a 3-D effect.

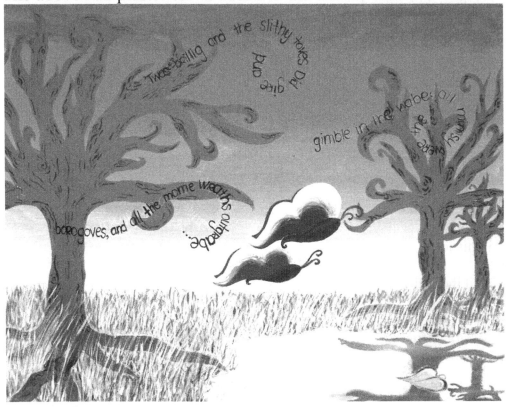

A: Please take 2 or 3 minutes to write about the following quote.

What is meant by the following quote?

"Don't pay any attention to what they write about you. Just measure it in inches."

~ Andy Warhol

B: Please take 2 or 3 minutes to write about the following quote.

What is meant by the following quote?

"Art lies in conceiving and designing, not in the actual execution—this was left for lesser minds." ~Leonardo da Vinci

C: Please take 2 or 3 minutes to write about the following quote.

What is meant by the following quote?

"Strain your brain more than your eye."

~Thomas Eakins

Question: How **or** why is a child a better artist than an adult?

D: Please take 2 or 3 minutes to write about the following quote.

What is meant by the following quote?

"The task of the artist is to make the human being uncomfortable."

~Lucian Freud

E: Please take 2 or 3 minutes to write about the following quote.

What is meant by the following quote?

"Colors are brighter when the mind is open."

~A. Alarcon

F: Please take 2 or 3 minutes to write about the following quote.

What is meant by the following quote?

"To be an artist at twenty is to be twenty: to still be an artist at fifty is to be an artist."

~Eric Gibbons inspired by Eugene Delacroix

G: Please take 2 or 3 minutes to write about the following quote.

What is meant by the following quote?

"O painter skilled in anatomy, beware lest the undue prominence of the bones, sinews and muscles cause you to become a wooden painter..."

~Leonardo da Vinci

H: Please take 2 or 3 minutes to write about the following quote.

What is meant by the following quote?

"Life is the art of drawing without an eraser." ~John W. Gardner

What does your home say about you or your family?

I: Please take 2 or 3 minutes to write about the following quote.

What is meant by the following quote?

"To make us feel small in the right way is a function of art; men can only make us feel small in the wrong way." ~E. M. Foster

J: Please take 2 or 3 minutes to write about the following quote.

What is meant by the following quote?

"I am interested in art as a means of living a life; not as a means of making a living."

~Robert Henri."

K: Please take 2 or 3 minutes to write about the following quote.

What is meant by the following quote?

"The world today doesn't make sense, so why should I paint pictures that do?"

~Pablo Picasso

L: Please take 2 or 3 minutes to write about the following quote.

What is meant by the following quote?

"Art is an effort to make you walk a half an inch above ground."

~Yoko Ono

M: Please take 2 or 3 minutes to write about the following quote.

What is meant by the following quote?

"I am an artist who, for forty years—Has stood at the lake edge—Throwing stones in the lake—Sometimes, very faintly—I hear a splash."

~Maxwell Bates

N: Please take 2 or 3 minutes to write about the following quote.

What is meant by the following quote?

"The artist uses the talent he has, wishing he had more talent. The talent uses the artist it has, wishing it had more artist." ~Robert Brault

O: **Please take 2 or 3 minutes to write about the following quote.**

What is meant by the following quote?

"We all have at least 100,000 bad drawings inside of us. The sooner we get them out and onto paper, the sooner we'll get to the good ones buried deep within."

~unknown~

P: **Please take 2 or 3 minutes to write about the following quote.**

What is meant by the following quote?

"He who wants to devote himself to painting, must begin by cutting off his tongue"

~Henri Matisse

Q: **Please take 2 or 3 minutes to write about the following quote.**

What is meant by the following quote?

"Bad art is a great deal worse than no art at all." ~ Oscar Wilde

R: **Please take 2 or 3 minutes to write about the following quote.**

What is meant by the following quote?

"It is as well not to have too great an admiration for your master's work. You will be in less danger of imitating him."

~Mary Cassatt

S: **Please take 2 or 3 minutes to write about the following quote.**

What is meant by the following quote?

"If people knew how hard I worked to achieve my mastery, it wouldn't seem so wonderful after all."

~Michelangelo

T: **Please take 2 or 3 minutes to write about the following quote.**

What is meant by the following quote?

"Art is not delivered like the morning paper; it has to be stolen from Mount Olympus."

~Wayne Thiebaud

U: **Please take 2 or 3 minutes to write about the following quote.**

What is meant by the following quote?

"Intelligence without ambition is a bird without wings"

~Salvador Dali

V: **Please take 2 or 3 minutes to write about the following quote.**

What is meant by the following quote?

"Only put off until tomorrow what you are willing to die having left undone."

~Pablo Picasso

W: **Please take 2 or 3 minutes to write about the following quote.**

What is meant by the following quote?

"The more horrifying this world becomes, the more art becomes abstract."

~ Ellen Key

X: Please take 2 or 3 minutes to write about the following quote.

What is meant by the following quote?

"Good art is not what it looks like, but what it does to us." ~Roy Adzak

Y : Please take 2 or 3 minutes to write about the following quote.

What is meant by the following quote?

"Artists can color the sky red because they know it's blue. Those of us who aren't artists must color things the way they really are or people might think we're stupid."

~Jules Feiffer

Z: Please take 2 or 3 minutes to write about the following quote.

What is meant by the following quote?

"Surely nothing has to listen to so many stupid remarks as a painting in a museum."

~Edmond & Jules de Goncourt

Art Principles of Design Sample

"Day and Night" by M.C. Escher

UNITY: Same-ness throughout an image:
 The whole image is in black and white unifying the picture through limited color.

VARIETY: (Contrast): Differences throughout an image
 The images have a variety of different things like birds, towns, rivers, and fields.

EMPHASIS: How one thing stands out above all others in some way.
 The white bird to the right stands out because it is so bright against the dark background.

RHYTHM/MOVEMENT: Describing how these can be suggested in an image somehow.
 The birds appear to be flying in opposite directions, giving a sense of movement.

BALANCE: (Symmetrical vs Asymmetrical Balance, Predictable or non-predictable balance)
 The image above is symmetrically balanced because the left is a mirror image of the right.

PATTERN: (Shapes, forms, lines…) Repeated motifs that create a predictable or unpredictable pattern.
 The birds create an alternating regular pattern in both their positive and negative space.
 OR: The fields in the background make a regular pattern like a quilt.

PROPORTION: Comparing the sameness or difference in the size relationships within the artwork.
 The white bird on the right is proportionally larger than the city below it because of perspective.
 OR: The white and black cities are proportionally the same size because they are mirror images.

Emotional Values of Shapes and Colors

There are some symbols in cultures that are the same everywhere. For instance, a puddle of red will be assumed to be blood; this would be the same in New York, China, or the jungles of some far off land.

Artists have been using these cultural symbols in their art to hide the meanings of their work or to code them. Here is a simple list. Remember shapes and colors can be combined for mixed emotional values. A heart shape is a combination of circles and a triangle.

 Triangles are associated with *SHARP* objects like a knife, a sword, broken glass, and spear. They are considered aggressive, dangerous, negative, and unbalanced. Triangles can be drawn in many ways to make them look more or less sharp.

 Circles are associated with SOFT objects like a balloon, bubble, or ball. They are considered playful, soft, energetic, positive, and happy.

Squares are associated with constructive ideas like building. They are regular, stable, strong, dependable, and at times, monotonous. Stretching the square into a rectangle can break up the monotony.

Red: Associated with blood, aggression, anger

Orange: Aggressive but not deadly. (Like Tackle Football)

Gold: A color of richness and wealth. Also a color of accomplishment. (Like a Gold Award)

Yellow: Playful, warm, enthusiastic, giddy, and child-like

Green: A color of growth. The type of green can indicate freshness

Blue: Associated with the sky or water, it is vast, cool, quenching, life-giving, and generally positive

Purple: A deep dark sky, royalty, peaceful, calm, and quiet

Black: A color of mystery or the unknown, also a color of heaviness and matter

Brown: Earth, soil, dirt. A color of potential growth, possibilities, a new beginning, or the end

White: A color of light, spirituality, and purity

MIXING colors will give new meanings and associations, so will using colored patterns.

Color Vocabulary

This vocabulary may be on an exam, along with your 8 Art Element Information and Art Principles of Design. Pages refer to the textbook *The Visual Experience.*

Value (page 92) The intensity of a color, its saturation as compared to another color. "Pink has a lighter value than red, but a darker value than white."

Shading (page 93) Changing the value by adding black or white.

Chiaroscuro (page 93) Italian word for light and dark. It is the change in the highlights and shadows.

Spectrum (page 96) White light separated into its primary and secondary colors. They are in order: red, orange, yellow, green, blue and purple.

Hue (page 96) Is the actual color without shade or highlight.

Primary Colors (page 97) The 3 colors that mix to make every other color. (red, blue, yellow)

Secondary Colors (page 97) The first mixes of the primary colors. (orange, green, purple) KNOW how to make each secondary color!!!

Intermediate Colors (page 97) These are the colors between the primary and secondary colors, sometimes called tertiary (Ter-She-Airy) colors.

Complementary Colors (page 97) Colors on the opposite sides of the color wheel, considered direct opposites like red and green.

Analogous Colors (page 97/98) Neighboring colors on the color wheel, like yellow and orange, or blue and green.

Monochromatic Colors (page 98) Different values of the same hue or color. Changing one color from light to dark. A black and white photo is monochromatic or one all in blues…

Intensity (page 98) The brightness or dullness of a color.

Color Harmonies (page 100) Colors that are grouped together for effect. Generally analogous colors are considered harmonious or varying versions of a single color. (see monochromatic).

Warm Colors (page 102) Colors that are more energetic and seem to come forward. When you think of fire, you'll know these colors are red, yellow and orange.

Cool Colors (page 102) Colors that are less energetic and seem to recede. When you think of water, you may recall that these colors are blue, green and purple.

Sample Test

1
2
3
4
balance
black
brown
circle
color
cone
cool
cube
cylinder
dark
depth
element
form
length
light
line
mass
negative
neutral
point
positive
primary
rectangle
reflected
secondary
shadow
shape
space
sphere
square
texture
triangle
warm
white
width

All possible answers are in the list on the left. Some answers are repeated, some are never used. Crossing off answers may not be helpful. The "#" sign means the answer is a number.

A line is a _____ moving through _____. We can measure the _____ of a line and nothing else, therefore it is _#_____ dimensional or _#_____ -D.

A _____ that intersects itself will create a shape. A shape is _#_____ dimensional. There are _#_____ basic shapes. The one with the fewest amount of sides is the _____, and the one with the most sides is the _____.

A _____ that moves in _____ can create a form. There are _#_____ basic forms. The one with the fewest amount of sides is the _____. The one with the most sides is the _____.

There are _#_____ basic colors. Basic colors are also called _____ colors. When these basic colors mix they create _____ colors of which there are _#_____. Color is _____ light. Orange, Red and Yellow are considered _____ colors, while Blue, Green and Purple are considered _____ colors.

_____ refers to the weight of something; sometimes it is real and sometimes it is the way it looks. A _____ colored box will look heavier than a _ _____ colored one.

The roughness or smoothness of a surface refers to its _____. It can sometimes be made by repeating an art _____ many times.

All objects, art and non-art, take up _____. Many art elements move through it. This art element comes in 2 types, they are _____ meaning where the object IS, and _____, meaning where the object is NOT.

The art element of _____ helps us see all other art elements. We see everything because it is _____ off of an object or surface and back to our eye. When it is NOT bounced back to us we see _____.

Principles of Design

What does **Balance** Mean? Having an equal amount of stuff or visual weight in an artwork.

Symmetrical Balance = Perfect Balance.

Asymmetrical Balance = Unequal stuff, but still in balance, (A brick /giant bag of feathers)

What does **Movement** Mean? Having a sense of direction, sometimes actual movement (like in a mobile) In a cartoon it can be shown with "swish lines", in a painting it may be in a blur, or an area where there is gradual or rapid change or repetition. Blur in a photograph indicates movement.

Does a sculpture have to actually move to have "Movement?" NO, it only needs to look like it could move.

What is **Rhythm**? Repeated elements making a visual rhythm.

It organizes space through repetition. This repetition can be predictable, complicated or unpredictable.

Does it have to be regular (predictable)? No, When unpredictable, we call that "organic" or of nature.

What is **Variety**? (Also called "CONTRAST") Having a diverse mixture of any art element, like shape or color to avoid monotony or boredom in a work of art. A painting that includes many colors, not just one.

What is the opposite of contrast? Unity or harmony. Remember that any art element can be contrasted, just find its opposite. There are 8 art elements like line, shape, color, form, light, texture, mass, and space.

What is **Emphasis**? A highlight of a particular area or thing.

Should the focal point be centered in an artwork? Not usually, but it can. A *little* off center is often true.

Where should it go? Anywhere but the center. As a general rule, putting something in the center of a painting makes it feel less like movement, like a portrait. Moving it to the side, a bit, makes it seem that it has a bit more visual energy.

What is **Pattern**? A repeated art element can create a pattern, like a repeated shape on a quilt, fabric, even leaves on a tree can be a pattern, though we would call that an organic (unpredictable) pattern.

What kind of artists use pattern? (Architects: brick pattern in a wall. Quilter…)

What 2 kinds of pattern are possible? Predictable (mechanical) and unpredictable (organic).

What is **Unity**? Having similarity in some way through an art element or material or theme. Like everything being red, or all parts made from squares…

What is the opposite of Unity? Contrast.

Please Note: Color mixtures, complimentary colors, analogous colors, triads, what colors mix well, which ones do not, primary colors, and secondary colors.

8 Art Elements Review

USE this information **WITH** Art Principles! Principles **organize** the Elements!

A **line** is a point moving through space. We can measure the length of a line and nothing else about it; therefore it is one-dimensional or 1-D.

A line that intersects itself will create a **shape**. A shape is 2-dimensional. There are 3 basic shapes. They are the triangle, circle, and square.

A shape that moves in space can create a **form**. There are 4 basic forms. They are the cylinder, cone, cube, and sphere.

There are 3 basic **colors**. Basic colors are also called primary colors. When these basic colors mix they create secondary colors of which there are 3. Color is reflected light. Orange, red, and yellow are considered warm colors, while blue, green, and purple are considered cool colors. KNOW color wheel and mixtures!!!! Complementary = opposite, analogous = neighboring.

Mass refers to the weight of something, sometimes it is real and sometimes it is the way it looks. A dark colored box will look heavier than a light colored one.

The roughness or smoothness of a surface refers to its **texture**. It can sometimes be made by repeating an art element many times. For example if you draw 100 lines, they will no longer be seen as lines, but as a texture; like grass.

All objects, art and non-art, take up **space**. Many art elements move through it. This art element comes in 2 types; Positive Space, meaning where the object IS, and Negative Space, meaning where the object is NOT.

The art element of **light** helps us see all other art elements. We see everything because it is reflected off an object or surface and back to our eyes. When it is NOT bounced back to us, we see black, or nothing.

Schools of Art Posters
A Group Project

You will create a learning aid to help others understand your school of art. This will take on the form of a poster measuring 18 x 24 inches. It should include items listed below AND LOOK ATTRACTIVE. All our projects are graded based on neatness, completeness, originality, and following directions. Please do not fold or rip your poster.

All items on the poster should be flat. Projects getting a 95% or higher may be laminated and used as a teaching aide for future students.

You must include the following:
— Title
— General dates of art movement
— ART from that period IN COLOR (You may photocopy and color in)
— Label all artwork

Written information should include:
— Written history of that school of art
— 4 or more artists working in that period
— Each artist must be represented with an artwork on the poster

CLUES: If you saw a painting, how would you know it was from your "School Of Art"
— List or description of clues to know how to identify the art's school

Interesting Fact –Van Gogh went crazy because he held his brushes in his mouth and got slowly poisoned that way! Try and identify something unusual or interesting that can be said about the art, or one of its artists.

QUOTE: Include 1 or 2 famous quotes from artist(s) within your school of art.

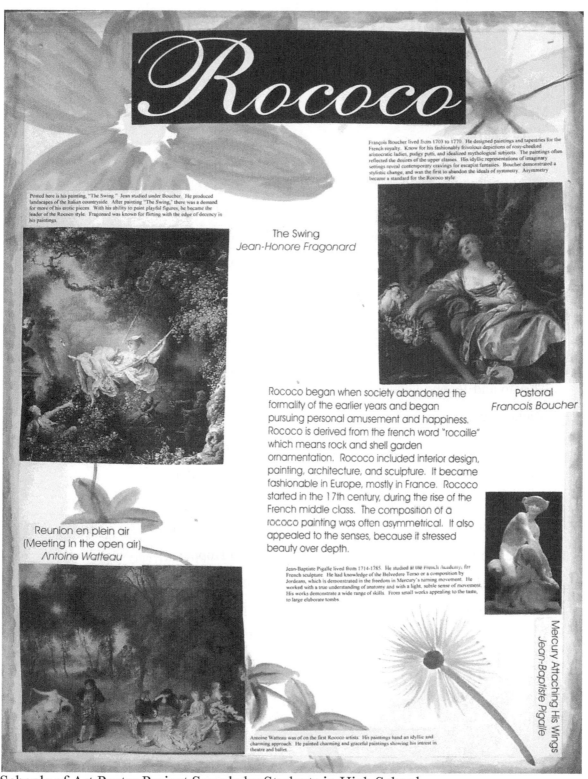

Schools of Art Poster Project Sample by Students in High School

Famous Artists for Possible Research

Pablo Picasso

Marcel Duchamp

Henri Matisse

Vincent Van Gogh

Claude Monet

Édouard Manet

Georgia O'Keeffe

Piet Mondrian

Paul Klee

Roy Lichtenstein

Claes Oldenburg

Christo and Jeanne-Claude

Michelangelo

Salvador Dali

Jackson Pollack

Mark Rothko

Paul Cezanne

Jasper Johns

Andy Warhol

Ansel Adams

Wayne Thiebaud

Georges Seurat

Rauschenberg

Albers Joseph

Grant Wood

Andrew Wyeth

Pierre Renoir

Chuck Close

M. C. Escher

Mary Cassatt

Alexander Calder

Rembrandt Van Rijn

Red Grooms

Dorothea Lang

Edvard Munch

Duane Hanson

Louise Nevelson

Raphael

Frank Stella

Romare Bearden

Frida Kahlo

Katsushika Hokusai

Edward Hopper

Jacob Lawrence

Henri Rousseau

Marc Chagall

Augustus Rodin

Norman Rockwell

George Segal

Artist Research Paper / Test Grade

THIS is a Major Grade counting as a test. _____ % of your _____ quarter grade.
Work copied from the Internet or plagiarized will be a zero and referred to the office for disciplinary action.
Use the Internet or library to find information, just... PUT IT IN YOUR OWN WORDS. Read, Understand and then Write.

Pick an artist you like, look in our textbooks for ideas.

You must write a one page paper about an artist and their work plus include a photo and cover page.

You MUST include the following Information:
— His/her name
— Birth and death dates and location
— "School of art" (This is the name of the style of their art, like Surrealism, Impressionism etc.)
— Basic history (life story)
— Describe his/her work in general and what is it that makes it unique or special
— Write about 1 work of their art; explain its meaning, or significance
— Include a copy, photocopy, print-out of the painting you are describing on a
 separate page. Label it!
— Simple bibliography on cover page

Paper Specifications:
— 1 full page. (It may be longer for extra credit, or to be sure paper is complete)
— 1 inch borders/margins all the way around
— 12 pt font (Simple font like this one "Times Roman" is good)
— SINGLE SPACED with NO spaces between paragraphs. (See the sample)
— Cover page with your name and additional information. (See the sample)

ALL WORK IS CHECKED FOR PLAGIARISM!. Don't copy work!

DUE DATE _____, _____ points off for every day late.

A SAMPLE PAPER IS ON THE NEXT 3 PAGES

Your Name
Period

Artist's Name
Birth/Death Dates
School of Art

Bibliography

Book Title, Author, Publisher, ISBN
Or full web address
http://www.artcyclopedia.com/artists/hassenflaffa.html

Arthur Framanmatt was born in 1892 in New York City and died in 2001 in his beloved Antarctica. He was a surrealistic painter who was fascinated by painting fruit pits and animal droppings, which he included in every painting.

Although born in New York he was raised on the top of Mount Fuji by his adopted Egyptian family; famous fur traders in Orient. His mother specialized in selling seas shells by the sea shore, while his father was well known for his "Peter Piper" brand pickled peppers. Arthur's first fascination was in drawing rubber baby buggy bumpers at a nearby factory. He was often observed by the factory custodian while drawing and became an apprentice, soon covering the walls of the factory with murals of all kinds. Here we began to see the inclusion of peach pits with a few apple seeds incorporated into his designs of giant wooly mammoths covered in French braids. His sense of realism was frightening and eventually lead to the closure of the factory.

Framanmatt attended Burlington County Community College in his 80's, getting an advanced degree in fine art. He was commissioned by the college to create more murals, these became, what are known today as, the Dung Murals. Though fully recognized for their genius today, at the time of their installation, they were reviled.

Later the artist co[...]style, though miniature, for the Bordentown Street Fair. Th[...]sold to a major New York gallery owner. This gallery brought [...]ding several successful exhibitions where his "Dung and Seed" [...]usand dollars each.

Arthur experimented [...]ding Gum Wads, Pastry Crumbs, Kitty Dandruff, and the mod[...]is photographs of belly-button lint. His works can be found in m[...]ling the Museum of Modern Art of New York, Los Angeles, Par[...]ands.

Arthur is one of a sm[...]hool of art who created an offshoot called "Da-Dee" art. It is k[...]s and the addition of odor to their works of art. Other Famous [...]Dyapar, Samual Steekey, Michael Farfrumfartin, and Jennifer [...] with the artist and her own series of pastries made from urinal [...]

Report Sample:

12 pt. Font
1 Inch all around margins
NO Breaks for paragraphs
No wasted space.
1 FULL Page.

It is okay to have more, but NOT LESS.

The attached work is called *White Polar Bear in a Snowstorm* where the artist uses his lesser-known technique of white on white on white. All the elements of the painting are shown through the subtle use of texture and odor. Here Framanmat ground up natural elements and ads them to his paint to suggest all necessary texture and even odors of the scene. Though some visitors have complained about the robust aroma, most galleries offer clothespins for their patrons. This particular work was completed in the spring of 1999 on the eve of the New Year. The artist assumed it would be his last work as he believed the earth would be consumed by fire the next day. His great disappointment led to a deep depression and precipitated his move to Antarctica and his eventual death there in 2001. Recent video images do conclude that he was viciously attached and killed by a pack of wild rabid penguins.

His wife, Ru Paul, is now the head of the family non-profit foundation, authenticating work from their Camden Apartment. She continues to speak on his behalf and is in communication with Stephen Speilburgh to make a film of her husband's life and eventual death at the flippers of psychotic penguins. Danny Deveto may be making a return to the silver screen as the lead blood-thirsty penguin, while Mel Gibson will play Framanmat.

Though Arthur Framanmat is dead, his legacy lives on in museums around the world and the continued growth of clothespin factories everywhere. Though much of his work remains hidden in vaults and private collections, exhibitions of his work still bring in crowds wherever his work hangs. A retrospective of his life's work was on display in the laundry room of the Ritz Carlton of NYC in 2001.

White Polar Bear in a Snowstorm, by Arthur Framanmat, 1999

Schools Of Art Introduction

Find these schools of art in the textbook *The Visual Experience*, or another resource. Read the entry and UNDERSTAND what makes the style so unique it needed a name. After reading the entry, Note its general time period, and define that school of art below. Be sure to explain how you would know a painting is of that style. Then add the names of 2 artists in that style on the 2 blanks provided.

1. Renaissance: page 428. Approximate Dates:_____

Definition:

What are key elements of this style?

2 Artists: _____ & _____

2. Baroque: page 446. Approximate Dates: _____
Definition:

What are key elements of this style?

2 Artists: _____ & _____

3. Rococo: page 450. Approximate Dates: _____
Definition:

What are key elements of this style?

2 Artists: _____ & _____

4. Neo-Classical: page 451. Approximate Dates: _____
Definition:

What are key elements of this style?

2 Artists: _____ & _____

5. Romanticism: page 452. Approximate Dates: _____
Definition:

What are key elements of this style?

2 Artists: _____ & _____

6. Realism : page 453 & 444. Approximate Dates _____
Definition:

What are key elements of this style?

2 Artists: _____ & _____

7. Impressionism : page 454. Approximate Dates _____
Definition:

What are key elements of this style?

2 Artists: _____ & _____

8. Expressionism: page 458. Approximate Dates _____
Definition:

What are key elements of this style?

2 Artists: _____ & _____

9. Cubism: page 460. Approximate Dates _____
Definition:

What are key elements of this style?

2 Artists: _____ & _____

10. Dada: page 462. Approximate Dates _____
Definition:

What are key elements of this style?

2 Artists: _____ & _____

11. Surrealism: page 462. Approximate Dates _____
Definition:

What are key elements of this style?

2 Artists: _____ & _____

12. Abstract Expressionism: page 465. Approximate Dates _____
Definition:

What are key elements of this style?

2 Artists: _____ & _____

13. Pop art: page 466. Approximate Dates _____
Definition:

What are key elements of this style?

2 Artists: _____ & _____

14. What style seems the most interesting and why?

Schools of Art Overview
List 3 facts about each school of art

Renaissance

1. _____
2. _____
3. _____

Baroque

1. _____
2. _____
3. _____

Rococo

1. _____
2. _____
3. _____

Neo-Classical

1. _____
2. _____
3. _____

Romanticism

1. _____
2. _____
3. _____

Impressionism

1. _____
2. _____
3. _____

Realism

1. _____
2. _____
3. _____

Cubism

1. _____
2. _____
3. _____

Dada

1. _____
2. _____
3. _____

Surrealism

1. _____
2. _____
3. _____

Expressionism

1. _____
2. _____
3. _____

Abstract Expressionism

1. _____
2. _____
3. _____

Pop Art

1. _____
2. _____
3. _____

Schools of Art List

Renaissance – French term for "rebirth," This work showed Greek, Roman or bible influence, often included perspective, the newest discovery of that time. It is the oldest style we have studied. Some artists would include Leonardo da Vinci, Michelangelo, (and the other Ninja Turtles).

Baroque – Looks like it might be on stage or dramatically lighted. Look for drama in the action or the lighting. Often has a large contrast in dark and light for more drama, but not always. Musketeers style clothes.

Rococo – Sickeningly Sweet, everything is rosy and RICH, often with mild sexual play with the frivolous rich. Cute and Fluffy were their main concerns. Their buildings too were covered with ornate decoration. Rococo took the drama of Baroque and topped it off with a tub of Sugar.

Neo-Classical – A direct contrast to Rococo. The Neo-Classists were the artists helping to bring down the Royalty and expose their selfish nature. They painted scenes of Calm Grandeur, always highly organized, noble. VERY organized, often with obvious geometric poses. These images often included Greek and Roman Influences so be CAUTIOUS to not confuse it with Renaissance. Nearly all buildings in Washington DC and its sculpture are the purest examples of this style.

Romanticism – In the early 1800's, a movement in art that embraced a more dramatic, personal and emotional style. It usually depicted Man and Nature at a very simple level, not always peaceful. The romanticists tried to paint a place before law ruled our lives. Man is never dominating nature in this work, though the opposite may be true.

Realism – The attempt to represent people, objects, or places in a realistic manner as opposed to an idealized way. Realism showed the good and the bad. These look most like photographs, not *JUST* realistic.

Impressionism – Beginning in France in the 1860's, a significant art movement and style of painting where artists attempted to paint their subjects in a way that showed the changing effects of natural lighting throughout the day. Monet, Cassatt, Van Gogh, Cézanne, and Pissarro are members of the group of Impressionist painters. Paintings are usually THICK with paint. They were interested in giving an "Impression" of the scene, it's LIGHT, not a photographic representation. The name comes from Monet's "Impression Of A Sunrise." Paintings are done from observation. Many of these paintings are organized along a "Z" pattern for visual flow.

Cubism – Started by Pablo Picasso with his painting in 1907 of Demoiselles d'Avignon. Georges Braque was a friend who also painted in this style. Usually the subject of the art looks to be shattered, broken into geometric pieces, but you may still recognize what's going on.
NOT ALL GEOMETRIC WORK IS CUBISM!

Expressionism – Must have recognizable images but an art element is used to express emotions. Though all art generally shows emotion, the artists of this school of art use color or shape to help enhance the emotions of the art.

Abstract Expressionism – NO Images can be seen. The work looks like splashes, or layers of color or child-like. *If you can't tell at all what's going on in the painting it is probably this style.*

Dada – A controversial art movement begun in Germany in the early 20th century. Works reflected cynicism toward social values and tradition. The artists employed unusual methods and materials in their works. It is Art of the Absurd or Silly. (Like a toilet up-side-down.)

Surrealism – Style or movement starting in the 1920's which was influenced by psychology's focus on dreams. Works in the Surrealist style often appear dreamlike, irrational and fantastical in their presentation. Some contributors include De Chirico, Salvador Dali, and Joan Miro. They can range from images that simply look haunting or slightly "off" though you may not know exactly why, to images that are highly real and disturbing, to images that are playful and symbolic.

Pop Art – Developed in New York in the 1960's, a style of art that derives from mass popular culture including consumer products advertising, simple every-day objects and cartoon characters. Some leading artists of the style include Richard Hamilton, Roy Lichtenstein and Andy Warhol.

There are HUNDREDS of art movements, this is a short list of popular ones.

ABSTRACT is a term to mean "changed from reality" This can be slight or dramatic. ***Abstract is NOT a school of art, but a vocabulary term.**** When paired with expressionism it means the work has no visually recognizable imagery.
(Like a cat or cup or object you can see.)

Important Art to remember

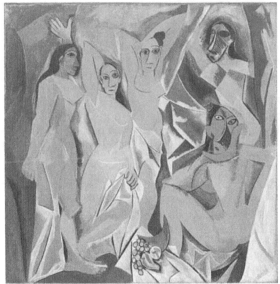

Pablo Picasso, **1907** of *Demoiselles d'Avignon.*

This is the FIRST painting EVER made showing a person in an abstract way. Though this may not seem like a great painting today, for its time it was RADICAL and HATED. Now we know it to be genius and the start of EVERYTHING we know as modern art. It is probably the second most expensive painting in the world, second only to the *Mona Lisa*, below by Leonardo Da Vinci, a Renaissance Artist from the late 1400s.

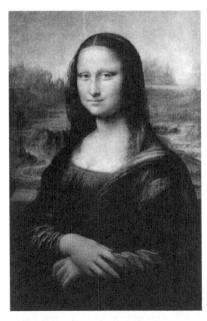

Many of our schools of art coordinate with
Other subjects like music, writing, theatre, and more.

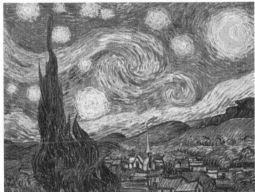

Starry Night, by Vincent VanGogh, an impressionistic painting, probably the 3rd most expensive painting after the other 2 on this page. This painting has all the hallmarks of a great Impressionist painting: "Z" pattern, bold brush stokes, focus on how light can be portrayed, an outdoor scene painted from observation.

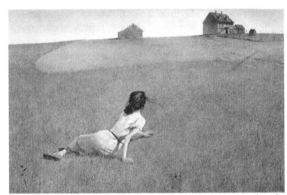

Christina's World by Andrew Wyeth is an example of Realism as it shows the flaws of the person in the grass. Often mistaken for a young girl, the subject is a handicapped older lady named… Christina.

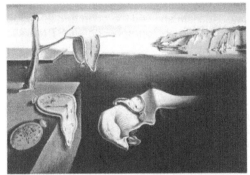

Persistence of Memory by Salvador Dali, is his most famous painting and of the surrealist school of art. Surrealists tried to make art that spoke to your subconscious and was very dream-like.

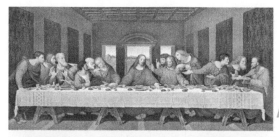

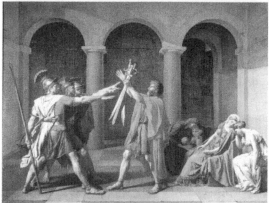

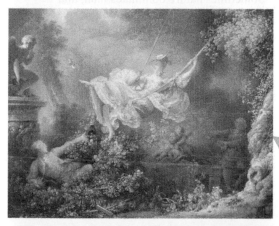

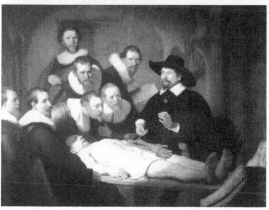

Schools of Art: Matching

Circle the description and draw a line to the image it belongs to.

Baroque: Highly organized and posed; Dramatic lighting like a spotlight: Older style but people wear the clothes of their time. People are not made to look better than they really are, so it's a bit more realistic. Musketeer style clothing.

Neoclassical: Highly organized and dramatic. Often includes a morality message. Created to look grand and important. People in the images often wear togas.

Renaissance: People in these images often wear togas but have relaxed poses. Though organized it is less dramatic than the other styles above. Often include themes from the Bible or mythology. Sometimes has hints of perspective.

Rococo: Usually includes images of the royalty of the time or the very rich. People in the images are often just playing or being a bit naughty. There is no morality message except to have fun. Trees and elements in the pictures have an overly "fluffy" appearance. Sickeningly sweet.

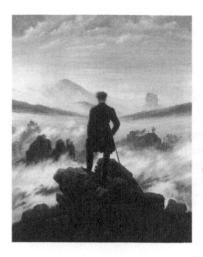

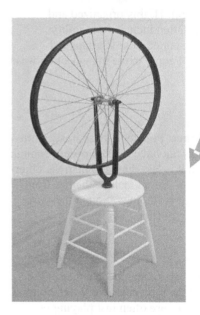

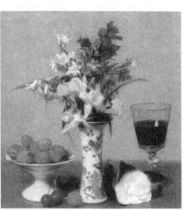

Circle the description and draw a line to the image it belongs to.

Dada: Art that looks the least like "ART." Sometimes considered absurd or an insult to art. Sometimes artists used simple common objects or random objects to be their art. It was very controversial but was a springboard for Pop Art which came later and is sometimes called *Neo-Dada*.

Romanticism: *NOT* about love, but the idea of man and nature together. Sometimes nature dominates man, and sometimes they coexist harmoniously. Man NEVER dominates nature in these images.

Realism: Is as it sounds, realistic. Images are created with attention to detail and showing things as they really are with their flaws and beauty. Sometimes this work has obvious brushstrokes, sometimes not. If it looks like a photograph it is likely this style or another called "photo-realism."

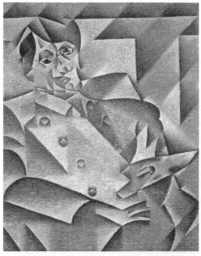

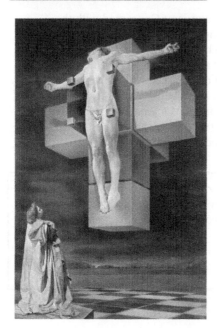

Circle the description and draw a line to the image it belongs to.

Surrealism: Sometimes very realistic but somehow impossible or dream-like. The style was developed based on psychological examination of dreams and symbols. Some of the work can be humorous, others can be haunting.

Pop Art: Generally colors are bold and vibrant. Images may be based on commercial products, common objects, cartoons, or images from popular culture. It is sometimes called *Neo-Dada*.

Cubism: Images often look shattered or reinterpreted with a geometric look. The subject is generally evident but is abstracted.

Circle the description and draw a line to the image it belongs to.

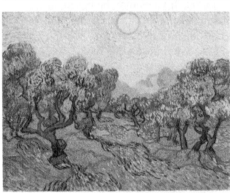

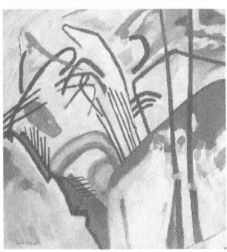

Abstract Expressionism: NO RECOGNIZABLE IMAGERY CAN BE SEEN. The meaning of the painting is derived from the colors, shapes, textures, or other art elements that the artist has chosen to manipulate. If you see something in the image, like an actual object (cat, cup, person) IT IS NOT THIS STYLE.

Expressionism: The artist uses one or more art elements (*color, shape, form...*) to express heightened emotions in the work. Joy, Anger, Pain, Love are some typical themes. In this style the subject can be easily seen though it may be a bit abstracted because of the expressive technique.

Impressionism: Concerned with the changing effects of light and depicting light. The work often includes bold brush strokes and textures. Sometimes a "Z" pattern can be seen within the work. Images are usually created from observation. Many paintings were created outdoors, but there are portraits, still lives, and more in this style.

Teacher: Though strictly speaking Van Gogh was a Post Impressionist, I feel that on a pre-college level it is helpful to express him as an Impressionist as he displays the key qualities of Impressionism in an exaggerated way.

ABSTRACT is a term to mean "changed from reality." This can be slight or dramatic. ***Abstract is NOT a school of art, but a vocabulary term.*** When paired with expressionism it means the work has no visually recognizable imagery. Abstraction can be slight to extreme; we can see this below.

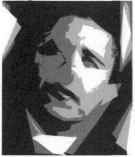

Realistic Photo Slight Abstraction Strong Abstraction VERY Abstracted

REMEMBER, if there is a subject, then the art is based on a real thing, and it cannot be abstract expressionism. How about below? Is there a subject?

Your teacher will be able to show you many famous painting samples. Decide what school of art they belong to based on clues you see within the artwork.

Sketch Below: What school of art do you believe it to be from?

What 3 pieces of evidence can you see?

1. _____

2. _____

3. _____

What was the real answer?

If you were wrong, what did you miss?

Sketch Below:

What school of art do you believe it to be from?

What 3 pieces of evidence can you see?

1. _____

2. _____

3. _____

What was the real answer?

If you were wrong, what did you miss?

Sketch Below:

What school of art do you believe it to be from?

What 3 pieces of evidence can you see?

1. _____

2. _____

3. _____

What was the real answer?

If you were wrong, what did you miss?

NOTE Taking

Project:_____ Date __/__/__

Sketch Page for: Project:_____ Date __/__/__

Video Notes

Video notes are an essential part of your grade and the easiest "A's" you will ever earn... Sometimes the teacher will be here for these videos, BUT a teacher does not need to be here to push "play" on a DVD. These assignments are mostly given when the teacher is out of school for a conference or something. These assignments are to help you learn about Art History, a mandatory part of all art classes.

The teacher could assign readings within a textbook and written assignments… or you could do a video once in a while…

To earn your 100% all you need is 20 facts about what you see. They can be things you hear the artist or moderator say, but they can also be things you observe in the video. Mainly the teacher needs to see evidence that you have watched the video and paid attention. **Two word facts are NOT acceptable.** Most students can get all the notes before the video is even half over. There is no excuse for not completing these assignments and getting 100%.

IF you are absent for the video, you will be excused from the assignment. Your name MUST appear as absent on the school's attendance roster. You may use a "Pass Point" instead of doing the notes, but this is a waste of a VALUABLE opportunity to raise a test grade. You will never be pestered into doing these assignments… it is after all, your own grade.

Some Art Videos on Youtube.com
This was a working list in the Spring of 2010.

http://www.youtube.com/watch?v=ub6GTjY031Y	Food Art
http://www.youtube.com/watch?v=1qdYJmiLV2Q	Hand Turkey
http://www.youtube.com/watch?v=s7GYGmEcQJA	Hand Art
http://www.youtube.com/watch?v=JjUMvnsE4zo	More Hand Art
http://www.youtube.com/watch?v=2itCiI-ykYg	Hand Shadows
http://www.youtube.com/watch?v=hibyAJOSW8U	Fake Face
http://www.youtube.com/watch?v=orjALWsyaR4	Burger Painting
http://www.youtube.com/watch?v=HVhVClFMg6Y	Kinetic Sculpture, BMW Spheres
http://www.youtube.com/watch?v=WcR7U2tuNoY	Theo Jansen
http://www.youtube.com/watch?v=b694exl_oZo	Theo Jansen
http://www.youtube.com/watch?v=PH6xCT2aTSo	Inflatable Bag Monsters
http://www.youtube.com/watch?v=fZvoqNiOnG4	Coffee Art
http://youtube.com/watch?v=rV5NLOL7Fjk	"Sand Dancer"
http://youtube.com/watch?v=Gw933kKz7w8	23 Scraps of Paper
http://youtube.com/watch?v=EkUbYBo5xgs	Banksy in the Museum
http://youtube.com/watch?v=SIf3dfqIVg8	Lobo Skank Onesong
http://youtube.com/watch?v=JwsBBIIXT0E	Reverse Graffiti
http://www.youtube.com/watch?v=zl6hNj1uOkY	Doll Face
http://www.youtube.com/watch?v=i1wfWPtjxMA	Dirt Painting
http://www.youtube.com/watch?v=ONqgaVU_XPk	Cube Animation
http://www.youtube.com/watch?v=vPIpvFtZ4-k	Makeup Artists
http://www.youtube.com/user/notblu?blend=1	Blu Art, Animated Drawings
http://www.youtube.com/watch?v=awKJQ-HfEHc	Shepard Fairey (Obama Hope Poster)
http://www.youtube.com/watch?v=iXT2E9Ccc8A	Salvador Dali
http://www.youtube.com/watch?v=lRai9x8aD3A	Bansky London Show
http://www.youtube.com/watch?v=3SNYtd0Ayt0	Street Mural
http://www.youtube.com/watch?v=f4zoQSNX1Ys	Electronic Garden
http://www.youtube.com/watch?v=NZsqd-OgKhE	Vogal Art Collection
http://www.youtube.com/watch?v=BDlLh0jcJVY	60 minutes: Is this art?
http://www.youtube.com/watch?v=0CFPg1m_Umg	Spraypaint Art
http://www.youtube.com/watch?v=ghqoqz3yvts	Spraypaint Art
http://www.youtube.com/watch?v=eftdfXNICbY	Paper Towers
http://www.youtube.com/watch?v=3Un20p1NGuw	Black Hole - Office
http://www.youtube.com/watch?v=NmxX2r-uD8I	Thief?
http://www.youtube.com/watch?v=OjTOs1L3SBg	InSide, Short Film
http://www.youtube.com/watch?v=ZxmvRDTELy8	Sliding House
http://www.youtube.com/watch?v=4HMm9jrgDzM	Artistic 1-10 in Japanese Theme
http://www.youtube.com/watch?v=d2Y5mUJiaZI	Duchamp's Fountain
http://www.youtube.com/watch?v=QrtCcXXNcGA	Coin Making
http://www.youtube.com/watch?v=BM-JpePRWB8	Coin Manufacture
http://www.youtube.com/watch?v=10gStfTPBfg	Relief Sculpture
http://www.youtube.com/watch?v=HdXNWH06mPc	Tourist Trap Animation
http://www.youtube.com/watch?v=pLAma-lrJRM	Twitch Art

YOUTUBE Video Notes DATE_____

Just write the title of the video and a short sentence about what you saw. 1 per video. As always, 1 and 2 word statements do not count.

1. _____ | _____
2. _____ | _____
3. _____ | _____
4. _____ | _____
5. _____ | _____
6. _____ | _____
7. _____ | _____
8. _____ | _____
9. _____ | _____
10. _____ | _____

YOUTUBE Video Notes DATE_____

Just write the title of the video and a short sentence about what you saw. 1 per video. As always, 1 and 2 word statements do not count.

1. _____ | _____
2. _____ | _____
3. _____ | _____
4. _____ | _____
5. _____ | _____
6. _____ | _____
7. _____ | _____
8. _____ | _____
9. _____ | _____
10. _____ | _____

VIDEO NOTES – GRADED ASSIGNMENT

TITLE_____

Period____ Date ___/___/___

Directions: Write 20 facts below based on the video WHILE YOU WATCH. **Two word facts, silliness, and incomplete thoughts will not be acceptable.** *This is GRADED as part of 10% of your quarter's grade.*

1. _____
2. _____
3. _____
4. _____
5. _____
6. _____
7. _____
8. _____
9. _____
10. _____
11. _____
12. _____
13. _____
14. _____
15. _____
16. _____
17. _____
18. _____
19. _____
20. _____

Double check that all facts have MORE than 2 words.

GRADED BY TEACHER: FULL CREDIT 100% OR _____% Credit

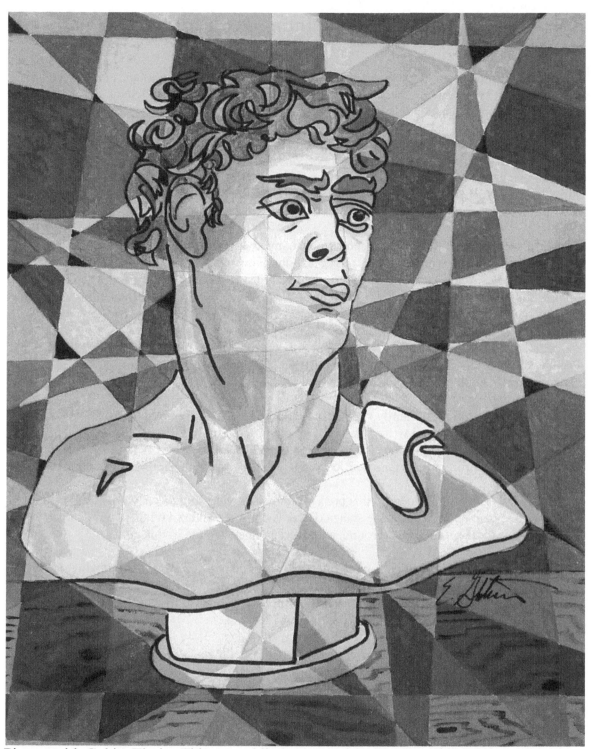

Picture with Cubist Tie-in: This was a blind contour drawing (Drawing while not looking at hands) of a statue. Then, a ruler was used to fracture the image, each shape painted differently with neighboring colors.

Drawing and Painting Project Ideas:

Some lessons can be augmented to work in different media.

Alphabets: [Problem Solving] Students pick a broad theme of their own interest and create an entire alphabet based on that theme. Objects should be in the shape of the letters. See supporting pages in this book. See examples in book.

Portraits: [Problem Solving & Eye-hand coordination] First without any instruction, then as blind drawings, then with exposure to proper proportions and finally with a grid. Students are assigned to bring in a photo of a family member or figure they admire. I have also done this project with a surrealistic component, where students mix a symbol of their personality and merge it with their portrait. See next page for an example →

Pop Art Pop: [Problem Solving] Students find a common object like a soda can, and re-draw and paint it in as many different modes as possible, blind drawing, contour, blind contour, stipple, crosshatch, color field. All work should be on the same size paper or canvas and when complete, images should be placed side by side to create a Warhol-inspired image. To make this easier, each student can be given a similar object and as a class create a larger mural-like project.

Tessellations: [Geometry] M.C. Escher. Plenty of support info on the net to do this. I like Crystal Productions' posters for this lesson. A Tessellation is a pattern that repeats infinitely. See example in this book.

Abstract Representation of Family with Shapes and Colors: [Self Expression] Students list 8 members of their family and write 5 descriptive words about each. Using the *Color and Shape Expression* worksheet in this book, they create symbolic shapes and colors for each and create a composition to represent their family. Klee and Kandinsky are good samples for work like this.

Jabberwocky: [Literature] Poem in this book. Without showing students any illustrations, they interpret the poem and illustrate one stanza. Work is collected and put on display. Include foreground, middle-ground, background, and overlap. See example in this book.

Cubism Simplified: [Geometry] Using a ruler, criss-cross a page in every possible direction with a pencil or pen. Choose an image from a magazine you like and "Force" the image into these geometric shapes. Seeing Picasso samples is helpful. Lines can also be used less abstractly to divide areas of color. Example on previous page in this book.

Comic Book / Movie Poster Parody: [Problem Solving] Taking a favorite movie, change the name a bit and create a new image for the parody. Include foreground, middle-ground, background, overlap, title, subtitle, logo, and dramatic action. (see sample in this workbook) See Warhol and Lichtenstein for Pop Art Samples of comic art. See example in this book.

Aboriginal Family Story: [World Cultures] Using samples of aboriginal paintings, and internet samples of aboriginal symbols, create a work that describes an important event from your own family history, recent or old, good or bad. Use the page of expressive shapes and colors to help. Fill all areas with pattern.

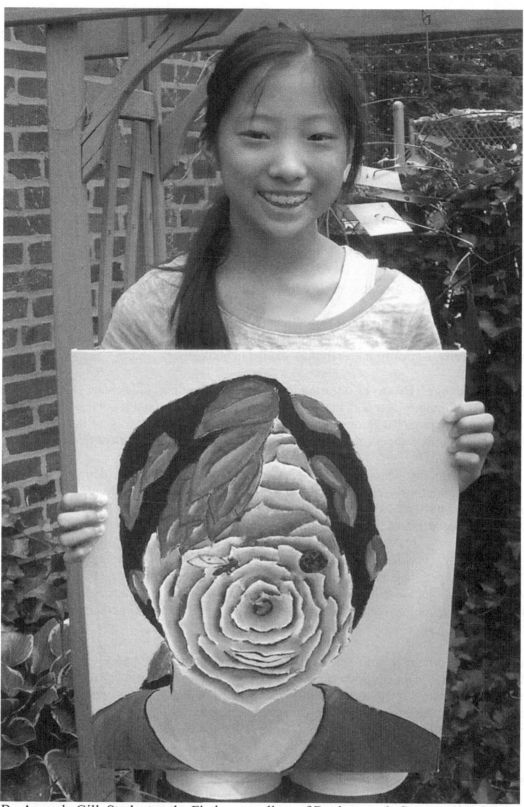

By Amanda Gill, Student at the Firehouse gallery of Bordentown's Summer Art Camp.

Drawings from Observation: [Biology] When weather permits, it is nice to go outside and draw a scene from nature. Make it fun by adding a surrealistic element, changing colors, or exaggerating elements within the scene. In spring-time it is fun to tag a branch when budding with loosely tied yarn, and redrawing that branch as a bloom grows. Andrew Wyeth is a good example artist here.

Sun Mandela: [World Cultures] See samples of Asian mandelas and create your own based on the sun as a theme. It can be done in watercolor with oil pastel resist. Consider the use of a cultural tie-in by asking students to use themes found in their own cultural background. Mandelas can also be made by using information from the emotional values of color and shape worksheet. By repeating shapes based on personality traits of themselves or family members they can cut these shapes from oak-tag and repeat them in a radial design. Corners of rectangular paper can be filled in too with the 4 seasons of ourselves either abstractly or with imagery. (FYI: Rubber cement is a good resist media too for bright whites, in well-ventilated area.)

Sunset Silhouette: [Problem Solving] Teach students to color blend with sunset colors, overlay black on the bottom quarter to create a land silhouette in black. Add in a tree, a man-made element and person in profile to complete it. See example in book.

Compound Word Illustration: [English] Create a list of compound words and illustrate them in a way that shows their incorrect meaning. Include foreground, middle-ground, background, and overlap. (Butterfly, a stick of butter flying) See list in book.

Wild World Collage: [History] Collecting images from magazines, kids create crazy combinations of images (Jets with butterfly wings, people with animal legs etc…) All of this is glued down to one large background image. Wavy Gravy is a collage artist of the 60's. Themes can be chosen, like current events or an event in history to create a historical tie-in.

Perspective: [Geometry] One-point perspective of a school hallway. Use rulers and worksheets in this book to prepare for the project. At the end I have students add in 1 surrealistic element to make the scene subtly spooky or funny. (Ninja dropping in from ceiling tile, T-Rex tail coming out a door…) See artists of the Renaissance for good examples of perspective.

Cut-Out Still Life: [Problem Solving] Do a large contour drawing of a simple still life. Behind this layer newspaper, magazines, construction paper, etc… Staple this packet and cut out contours. Reconstruct the still life on a new paper mixing layered cut-outs. Add drawing lines on top for shading and define contours as needed. Picasso and Braque had good examples of work like this.

Environmental Drawing: [Earth Science] Teacher will need to have MANY examples set aside. Students create their own environment (Desert, forest, jungle, coral reef…) and use examples from teacher showing how things should look. No one should draw from imagination but mix and match images from several sources to create one complete image. All elements come from observation of available images. (I get books at Barnes and Noble on super discount, cut them up and laminate the pages) Students are to include foreground, middle-ground, and background.

Dream Drawings: [Psychology and Self Expression] Using J. Miro as an example or Klee, students re-create an image from a persistent dream. Include foreground, middle-ground, and background. See example in book. Discuss Freudian dream symbolism is appropriate.

Puppetry project, made from non-composite carpet foam, staples, pliers, and hot glue. Each student created a creature that would best express their hidden personality. T-Shirt for body.

7 Step Transition: [Geometry] Using a long strip of paper, students draw 2 objects, unrelated to each other, on opposite ends. In 7 steps (including the 2 images) students show a transition or "morph" of one image into the other. (Scissor turning into a coke can in 7 steps.)

Treasure Maps: [Geometry/Geography] Students create a treasure map of an imaginary island. The island can take on the contour of an object, but break it into small pieces so it is not too obvious. Include the following: Detailed border, rose compass, longitude/latitude, 5 land feature symbols, key for symbols, 2 landmarks, 2 water symbols in the water, 1 sea monster and 1 ship. Maps can be aged by wrinkling and soaking in watered-down paint. See example in this book.

Wrinkle World: [Problem Solving] Take a large piece of paper, wrinkle it into a ball, open and stare at it, and trace shapes you see that make images. This is very similar to watching clouds and trying to see shapes and creatures in them. Color in and make as detailed as possible.

Trompe l'oeil: [History] Students create simple compositions on art-board with 6 - 8 personal symbolic objects. We start with a contour tracing of the board and use rules to measure and draw objects as realistically as possible on a 1-to-1 scale. Layering of colors is stressed as well as adding in realistic tone with regular pencil. See example in this book.

Flower Dissection: [Science] Drawing and labeling with research. Students can gather flowers or bring some in, maybe a donation of old flowers from a flower shop. Students dissect flowers with an X-Acto knife and draw from observation. Later, within the library or computer lab, students label the parts that they have observed. Enlarge sketches and use as references for larger paintings like Georgia O'Keeffe.

Drawings of Decay: [Science] Students can gather soft tissue plants, even lettuce can work and do one sketch a day of the decaying process. This could even be done in the form of a flipbook. Sketches can also follow the various color changes observed in the plant. I would suggest this as a five-minute sketch at the beginning of each class while doing another project. Sketches can later be more fully completed.

Flipbooks: [Science] of science based observations. Similar to drawings of decay, students could also make flip books based on observations of processes like cell division, plant growth, weather movements, etc.

Code Painting: [Math] Students can create a visual code of colors and shapes to represent numbers, letter place-holders, and functions, then illustrate a math concept through these colors, shapes, and composition. Pi as a color code, the quadratic formula, solving for unknown angles, etc. This can result in some very abstract works of art but reinforce the math concepts the students have chosen to base their work on. Images should be examined afterward to see if any larger patterns emerge.

Scavenger Hunt: [History] Students can be given 20 thumbnails of images to find via library resources or the internet. They should label the images as a kind of art history scavenger hunt. This can be taken a step further by requiring that the date of the image be found, the place of creation, and students find an historical event from that time and place to include in their scavenger hunt.

Board Game: [History] Students work in groups to create a board game based on an historical event or time period. Research will help them create playing pieces and images for their board games. Game board can be made with a canvas board or covered cardboard. A game can also be based on something the student is excellent at and knows a lot about, like skateboarding…

Political Cartoon: [Current Events/History] Students could create a political cartoon for a contemporary event or historical one, choosing a side to support for a clear point of view.

Mash-Up: [History] Students could make a satirical recreation of a famous work of art or combine two very different famous works to create a new one. There should be accompanying information about the images created that indicate student understanding of context.

Museum Tour: [History] Students can create a diorama of a museum hall setting up an exhibition of images from that particular time. Images should have a companion paper labeled with historical details of the works of art. This can be done for specific schools of art, artists, themes, or based on interests of the students. (ie: finding images of game playing from 8 different centuries). Larger exhibitions can be created as a group project, each group setting up an exhibition in the room for a day or week each.

Art History: [History] Students could take a famous event in human history and create a work of art based on that event. They can even be required to choose a school of art that was from the time of the event from which to create their artwork. (ie: WWI scene in expressionism style.)

Sculptural Projects

Some projects may be augmented to create 2-D projects as drawings or paintings.

Family Mobile: [Geometry/Physics] Students use information from this book about the emotional values of color and shape to create mobiles of their family unit by creating symbolic shapes and colors for each family member and create a composition to represent their family. (8 – 10 shapes recommended) Alexander Calder is a wonderful artist for examples. See example in book.

Dinosaur Eggs: [Science] Students create dinosaur eggs from plaster and balloons, then crack them open and create a baby dinosaur to fit inside as if in the process of hatching. Students research what their chosen dinosaur would look like as a baby. Eggs and creatures should be related by color to reinforce form and function concepts.

Wire Tree: [World Cultures] Using stovepipe wire or copper, students take 50 to 100 thin strands at about 1 ft in length and twist the wires to make a tree, splitting bunches and twisting roots and branches. Foil, craft jewels, or other leaf-like objects can be added as leaves. See the internet for many examples. Couple this project with research about Bonsai trees and their expressive forms.

Wire People/Portraits: [Problem Solving] Using thin wire, students create a self portrait. Include elements unique to themselves. This project can be extended by creating a body as well, doing an activity the student does often, or what they wish to be able to do. Students could also create a character from a circus. Alexander Calder did many examples of this too. See example in book.

Biome House: [Geography/Biology] Show students several biome posters from the biology classes. Environments can be tundra, desert, mountains, grasslands, rain forest, etc. Students choose their favorite; learn a bit more about it, and with foam-core or cardboard, create an architectural cottage or home that would fit within that biome. Above: woodland biome home.

Pen of Power: [History/World Cultures] Students take and carve an old branch adding feathers and other natural elements to make a shaman's pen. Students should have a discussion about Native American cultures and create the pen with this in mind. After adding a nib, pens can be used to do a drawing, write a poem, or even create a magical spell. See example in book.

Monumental Design: [History] Students create a miniature monument to an historic hero, an event they wish they could re-visit, or a monument to a personal achievement, or personal experience. There are many memorials from which to pull examples. See example in book.

Goal and Obstacle: [Problem Solving] Students create lists of life goals and things that may prevent them from these achievements. These lists are converted into symbols. The students then create a work that shows 1 of each. The Obstacle on the bottom as a base and the achievement above. (This can also be done with a box and doing different things with the inside and outside OR combine with the next project of Expressive Heads)

Expressive Head: [Problem Solving] (I use a foam head from eNasco for this project) Students create a blank head form to cover in a variety of materials to illustrate a personal or social issue they care about. Some ideas: Use magazines and cover the head with words, cover head with a map painting and add pins for places you've visited, destroy head and reassemble, empty head and fill with expressive items, alter the head for expressive reasons. See the artist Robert Arneson for examples. List on page 21 may be helpful for topic based sculptures. See example in book.

Self Portraits: [Problem Solving] Students create a plaster cast of their faces. Clay is pressed into these to create "Life Masks" which can be painted or glazed with many themes: life story on the face, achievement, my two personalities, inside/outside self, write a poem about the self on the face and others. Plaster mold can also be used to create multiple faces for a larger project, or to create a unique teapot, wall hanging, tile etc… by including pressed clay. See the artist Robert Arneson for examples. See example in book.

Lippold Crystals: [Geometry] Look up imagery by the artist Lippold. Students create their own crystals with any linear material. I use eNasco acrylic straws, pipe cleaners, and 527 glue. Students start simply and add on structures to make their project grow. They should learn about the necessity of structures that are rigid for project strength. Modular sculptures can be used too, so all work can be combined into a monumental work for display. See example in book.

Paper Structures: [Physics/Engineering] Students create the tallest tower possible with 4 large sheets of paper and 2 yards of tape. Structure must stand after teacher blows on it. Paper can also be used to design an amusement park, landscape all in white, a house of their dreams. Cardstock can be used to make modular rectangles, like playing cards and glued to create permanent card-houses.

Environmental Sculptures: [Problem Solving & Engineering] After seeing the work of Andrew Goldsworthy, students create their own environmental sculpture. Students can be broken into smaller groups to make larger structures. Work should be photographed, printed, and displayed.

Pop Art Food: [Problem Solving] After seeing the work of Claes Oldenburg, students create their own food sculptures on any scale the teacher requires. They could also sculpt a small everyday item in larger scale with paper or plaster mache. This project can also be done by making paper staple pillows, stuffed with scraps. (Two sheets of paper, stapled 80%, stuff with scraps, and staple closed. Similar to sewing but with staples and paper.)

Anti-Teapot: [Problem Solving] Create a teapot that does not look like a teapot. It should pour, be able to be held, but the form should be disguised. There are many samples on the internet. Pig teapot, house, dragon, egg, cabbage…

Word Sculpture: [English/Social Studies] Students take a word (Social issue, personal issue or topic they know well) Like "EARTH" and make each letter look like part of the issue you care about. The "E" could be a factory spewing toxins, the "A" could be a hurricane, the "R" could be melting, etc. A list of expressive words in this book may be helpful for topic-based sculptures.

Altered book by Claire Scala

Altered book by Gabe Nisula

Recycled Multiples: [Problem Solving & Recycling] When available in large quantities, discarded items can be used to create modular sculptures. Cups, plastic spoons, rings, etc. They should be organized by some theme; crystals, sun sculptures, towers…

Gargoyle of Protection: [World Cultures] Students create a list of their own phobias, and incorporate a symbol that would repel that phobia into their gargoyle. (Fear of the dark?) Their gargoyle may hold a light, candle OR be created with light colors. Combine with research about gargoyles of Paris—water symbols that were to ward off fire. (Japan uses dolphin symbols)

Revelation Mask: [History/World Cultures] Students create a mask based on a symbol that reveals part of their personality people are not aware of. The Mask is created to reveal the self rather than conceal. Couple this lesson with samples of masks from other cultures or historical periods. Consider a 2-sided mask expressing inner and outer personalities.

Plaster People: [Problem Solving & Construction] After seeing examples of the work of George Segal, students work in groups to make a plaster cast of a student engaged in a school activity. This sculpture should be placed in the school environment. I suggest casting parts each day and assembling parts at the end and stuffing them with paper. Face, back of head, body trunk, arms, legs. You will need tools to cut plaster safely from the body. Models wear OLD clothes as they will be ruined. Casts can be made in multiple 40-minute periods if well planned.

Masterworks: [History] Students reproduce a master painting in 3-D relief with plaster of paris on canvas boards. This can be a great tie-in for an art history unit. Students could also reproduce an artwork on an unusual surface like a chair, or re-do an artwork with an element related to the student's own interest, experiences, or symbol for themselves.

Mechanisms of Unknown Purpose: [Engineering] Appeared in *School Arts Magazine*. Students bring in non-working old mechanical items and disassemble completely. (Computers, hardware, vacuum, radio, TV, etc.) They re-assemble these objects to look like some futuristic mechanism that does something mysterious. They create a name and a small story about this strange object's purpose. See example in book. Safety is an issue to consider in the destruction phase.

Viral Sculptures/Pollen Sculptures: [Science] After researching the forms of micro-organisms by either internet, library, or microscopic observation, students re-create their sample in 3-D. Often these may begin with a paper or aluminum foil base and other items added to it. String, cardboard, pipe-cleaners, wire, etc. Once the initial form is complete, students can be encouraged to embellish these forms to go from clinical to artistic. Students should note the name of their source for their form. See example in book.

Talisman: [Archeology/History] Students create a "coin" negative in clay (Oil-based clay is best) then cast plaster into the form. Students can create a coin to commemorate an event, a talisman to protect them from something, a "charm" to do some imaginary magic, or fill it with objects that represent themselves. This lesson can be coupled with a lesson in archeological discoveries of Greek or Roman coins and imperial artifacts. Students can take on the persona of Caesar & create a coin to immortalize themselves and include symbols for their own strengths and points of view.

Structure: [Engineering] In either groups or as individuals students could build a bridge with limited supplies and create a contest to see how much weight that structure could hold. (4 x 24 inch dowels, 12 inches of masking tape, and wood glue) Similarly, students could create towers with limited supplies to see whose is the tallest and can withstand a fan placed on it (Emphasizing strength and height with 4 sheets of 18 x 24 inch paper, scissors and 3 yards of tape.) Also given 50 sheets of copy paper and 3 yards of tape, students create a structure that can hold books 8 inches or more above the surface of a table. Groups can complete to see whose group holds the most textbooks.

Altered Books: [Problem Solving & Recycling] *"Don't Judge a book by its cover."* Find a source for old hard cover books that are being discarded, many libraries have piles of these. Students then alter the book by painting in, cutting out, gluing in and outside the book. If you have too many books, one can be an experiment book to try out techniques, and the second for the actual graded project. Students should complete the worksheet in this book about how they are perceived by others and how they know themselves to be. Then generate symbols for these. The outside of the book should express how they are seen by others, and the inside is what they know about themselves. Encourage students to "code" their work from the worksheet about the expressive qualities of color and shape. In this way they can keep personal information private yet still express themselves.

Puppets: [History, Service Learning, World Cultures] Use non-particle carpet foam. Uniform 3-pound polyurethane sheets work well and are inexpensive, some carpet stores may even make a donation if asked. Students can create puppets of themselves, an expression of their personality, an historical figure, or specific characters similar to muppets. I find that pliers staplers are excellent for putting together puppets quickly, some glues will be helpful too but are often very smelly and toxic if air-flow is poor. Puppets can be made as historical figures, anti-bullying plays, or any subject. I like to make a performance part of the grade as well. My high school students perform for the neighboring elementary school.

Consumer Products: [Advertising Design] Students examine and break down the elements found on a can of soda, box of cereal, or other consumer product. They create their own consumer product that has the same kinds of elements as their samples. Label, form, logo, directions, imagery, title, subtitle, etc.

3-D Glasses: [Optics, Physics, Recycling, Environmental Sciences] By visiting most movie theatres, one may ask a manager for 3-D glasses often thrown away. Sanitize them for student use with Lysol or another cleaner. Partner with a science teacher to explore the technology of 3-D glasses and polarized plastics. They are pretty cool and do some interesting tricks. Glasses can be redesigned to become super-hero glasses by adding on sculptural elements, paint and craft supplies. They could make glasses they feel have a super power they wish they had. If you add recycled electronic items, they can look rather sci-fi high tech too. They may be painted with a theme of a particular school of art or artist. What would sunglasses look like if they were designed by Picasso, or Van Gogh? What might cubist sunglasses look like?

Wire Heads: [Self Expression/Problem Solving] Using soft annealed wire, students create a head based on their own face (Symbolically). This is then filled with objects representing things and skills that are "inside" the student. This is best coordinated with the Self Expression Worksheet early in this book to generate ideas. Inner objects can be created or actual objects brought in.

Wire Head Sample: Begin with simple base and add on features to make face.
Wear eye protection, cut wire can be very sharp. This sample is about life-size.

"A.R.T." plaster and acrylic paint.

185 SKETCHBOOK IDEAS

Many of these may be turned into actual projects, but these sketchbook ideas are meant to be done in 1 class period or less as a way to warm up for larger projects.

Baseline Drawing 1: Draw a shoe in as much detail as you can.

Baseline drawing 2: Draw yourself in a mirror with as much detail as you can.

Baseline Drawing 3: Draw your hand in as much detail as you can.

Fill a page with scribbles, and then look at them and reveal what can be seen in them. This is similar to looking at clouds and spotting objects in them, but here you color them in.

Rip a random small piece of paper from a magazine and draw it. Enlarge it to fill the page.

Draw the view through a window.

Write your name 30 times, in different sizes and directions, overlapping often to divide the page into many shapes. Color in using colors that express your mood today using the expressive colors and shapes worksheet.

Draw a tree from your imagination then draw a tree from observation. Which looks better to you? Why?

Trace your hand in an interesting position and turn it into an animal. DO NOT MAKE A TURKEY.

Find a common small object and enlarge it to fill your paper.

Draw yourself in a mirror but DO NOT look at the paper while you do it.

Draw a friend or family member with one continuous line. Do not lift the pencil until it is complete.

Find a tree and draw what is seen between the branches without drawing the tree itself.

Find a face in a magazine or photograph, turn it up-side-down and draw it up-side-down too.

Fill a page with shapes, get into every corner, but DO NOT lift your pencil until you are done. Color in using colors that express your personality using the expressive colors and shapes worksheet.

Draw some clouds from observation.

Draw your hand holding a CD. Draw as much of yourself in the mirror as you can see even if it is just a fragment.

Trace a leaf, trace the shadow it makes. Color in as realistically as you can like trompe l'oeil.

Trace your hand in an interesting position; fill it with patterns and color that express what you like to do with your hands.

Draw what you have in your pockets right now.

Draw a shoe, position the laces in such a way as to create a hidden face in your show. Draw it realistically but be sure to capture the idea of a face as well.

Take 2 unrelated objects and create a hybrid image of this new object. (Like scissors and a bird)

Spy on someone and draw them without them knowing.

Draw your meal or utensils.

Half fill a clear glass with water. Place 1 or 2 objects inside that are both in and out of the liquid (like a spoon or chopstick), draw it.

Take a common object that would relate to yourself, then repeat that object to make an animal that you also feel expresses your personality. Feel free to abstract and stretch the objects to make your animal.

Get a new pencil, do a drawing of something around you by holding the very end where the eraser is.

Write your name and a short statement in block letters, maybe a poem or memory, BUT do it with your eyes closed. Color in after you are done.

Using only color and shape, try to do a drawing that represents LOVE without using a heart.

Do a drawing of the feeling of WAR with colors and shapes and NO objects. Try other words.

Do a hybrid drawing of 2 unrelated animals as a new animal (lion & fish maybe). Be sure to have examples of both in front of you if possible.

Try to draw an object from observation as if you were looking at it through a shattered window or mirror.

Draw an object from observation but draw several points of view at the same time, overlapping.

Try to draw a moving object and capture the idea of that movement you observe.

Take a magazine image, cut it in half and paste onto a new paper. (Rubber cement works best) Complete the missing half by hand. Include shadows too.

Take the magazine image left over from the last drawing and paste on another sheet of paper. Complete the missing half in a strange and unexpected way.

Draw a childhood memory.

Using a reference like yourself, a friend, or picture, draw a detailed eye.

Draw the line that separates your lips. Note how dynamic this line really is. Finish by adding your upper and lower lips.

Draw a night scene from observation through a widow.

Draw a unique dragon.

Gargoyles are meant to protect you and scare away evil spirits. Draw and create your own gargoyle to keep one of your fears away from you. For example, if you have a fear of darkness, your gargoyle might hold a torch or emit light.

Find an un-illustrated poem & create a picture for it.

Draw a solid object from observation, but do it as if it were glass.

Tightly wrap an object with cloth. Be sure the form of the object can still be understood. Draw It.

Fill a page with an image that simulates the texture of rock. Have a rock as reference to look at.

Draw a coin but enlarge it to fill the page. Add shadows and shines to make it look 3-D.

Draw a still life with 5 objects but color them with the opposite colors than they actually are.

Draw the outline of an observed object. Create a negative by coloring highlights, dark shadows, and areas of light.

Set two very differently colored and textured objects side by side, but color & texture one with the colors & textures of its neighbor.

Draw the outlines of two objects and partially overlap the drawings. Color each with a different primary color, where they overlap color with the secondary color they would create.

Color in a whole page with gray, use an eraser to draw. Try to vary the tones you see. Finish by adding very dark tones with heavy pencil. Be sure erasures show.

Draw something as if you were losing your mind.

Create a black and white landscape with one object in color.

Sketch a new way to design the face of a clock.

Write a short poem backwards (Mirror Writing) with big bold overlapping block letters. Color in the spaces created with analogous colors (Neighboring Colors on the color wheel)

Create a cartoon of yourself or a friend.

Draw a portrait of a friend or yourself; color in by signing that person's name over and over. Layer names for shadows like crosshatching.

Draw a self portrait made entirely of objects that represent what interests you.

Create a logo for yourself; be sure that it contains a clue about your personality.

Draw yourself as a monster.

Set an object in a box. Draw the object in the box; include the inside of the box in your drawing.

Draw an outline of a simple object.
- Draw the object again without lifting your pencil.
- Draw the object again without looking at your hand while you draw. Try to do it with a mostly continuous line.
- Draw the object's outline and shade with crosshatching lines.
- Draw the object again and use scribble lines to create shadow.
- Draw the object again only using dots for color and shadow.

Take a pattered fabric or shirt, drape it over a chair and draw it showing the pattern changes as the fabric folds and drapes.

Draw an object from observation above. Color the light side with warm colors (yellow through red) and the shaded side with cool colors like purple, blue, and green.

Put together a group of similarly colored objects. Set them up on a contrasting or opposite color for a still life drawing.

Draw a flag that would represent your family. Try to be symbolic. Use the worksheet in this book on the expressive qualities of shapes and colors.

Draw something from an unusual point of view.

Draw your hand drawing your hand in a funny way. (M.C. Escher did something like this)

Find a small simple, common object. Draw it large and turn it into an architectural design.

Draw your head realistically or as a cartoon. Add a large hole or opening to it and have objects escaping from that hole that tell a story about what goes on in your mind.

Trace an object about the size of this page, onto a page. Turn it into a very different object by how you finish the drawing. A pair of scissors may become a bird. You may add onto the object as you wish, try not to erase much of the original outline.

Cover half of your face with an object, and then create a self portrait.

Draw an original super hero with a power you wish you had.

Draw a stabbed object. (Like a piece of fruit with a pencil stabbed into it) Make the drawing with exaggerated sense of emotion.

Draw someone talking. Fill the background with their words in a creative way. This could be a historical figure or someone around you today.

Draw something flying that would not normally be able to fly.

Write an expressive word in large fat bubble-letters. Fill in the letters with images that relate the meaning of the word.

Draw an animal based on a photograph of it, BUT only draw it with letters found in its name. It is okay to abstract the letters to make them fit. Use the colors of the animal to finish it.

Design an item of clothing, color and texture it.

Draw the kind of house you would like to live in.

Draw your hand pointed away from you toward an object, draw both your hand and the object. Overlap a bit if you can to add realism and a hint of perspective.

Use candles, burn sticks and draw a still life with home-made charcoal.

Draw a wall with windows, and details of adjacent items like bookshelves, chairs, etc. Then draw an unexpected environment through the window.

Draw yours or a friend's face, divide it into 4 parts, and color each section with symbols for 4 things that are important to that person.

Trace your hand and draw what might be inside if you were an awesome robot.

Paste down half a face from a magazine. Choose an attractive model. Finish the other half of the face as if they were an alien.

If you could design your very own cell phone, what would it look like?

Draw a container, and on the back draw something unexpected that would be inside the container. Hold the page up to the light to see an x-ray view of both.

Design a piece of jewelry and use a symbol from your own cultural background in it.

Draw a piece of foil with a few wrinkles in it.

Place a coin under a page, rub a pencil over the page to create an embossed image. Then draw your hand holding the coin.

Draw a design you think would make a cool tattoo for you. Remember that tattoos are often symbolic of thing important to the person wearing it.

Draw the *thing* that lives under a child's bed.

Draw someone's ear from about 6 inches away from them. Be so close you can see every detail.

Using a flashlight, draw an object and its shades and highlights, but light it from an unusual point of view. (Like a face with the light below the chin, or still life lit from below.

Crumple a page, flatten it lightly so the creases are still obvious, then draw the page.

Draw a CD cover for your favorite song.

Draw your home as a castle but include details that are there right now.

Crumple this page, lightly flatten it, and trace the wrinkles making what you can imagine into the creases. This is similar to finding objects in clouds. As you stare, object will become apparent.

Draw something dry as if it was wet.

Have a friend lay down on the floor. Draw their portrait while sitting above their head so their face is up-side-down. Your drawing will be up-side-down as well.

How would you re-design your hand to be better than it is? If you were into basketball, how might it be different? Consider your hobbies and activities.

What might a flower look like on an alien planet?

Design a new cologne bottle for either a great scent, or something very bad.

Willy Wonka remade an environment out of candy, what would you draw an environment out of?

Create a new label for your favorite beverage.

Pick a playing card and do a design based on that card that no linger looks like a playing card. Use repetition and pattern if it helps.

Create a cover for a ridiculous comic book.

Draw something in the room no one notices.

Lay on the floor and look up. Draw part of the room with this unusual perspective.

Put your leg up on the table and draw your leg, shoe and all, in perspective.

When you cross your eyes, you see double. Draw something around you as if you had double vision. Find a creative way to handle overlapped areas.

Do a portrait of a friend, but re-imagining their hair in a way that shows off their personality.

Draw the trophy you wish you could win.

Draw the first thing you would buy if you won the lottery.

Draw your hand holding your favorite possession.

Draw what it looks like sitting in the front of your car, and put something unexpected in the rear-view mirror.

Draw something pretty next to something ugly.

Draw a piece of popcorn to fill this page.

Draw something floating in a magical way.

Hold a tube of paper up to your eye and draw your point of view. (If you have glasses, maybe you can tape a small tube to them.)

Stand on something tall and draw your view looking down.

While lying on the floor, draw what you see from that perspective as if you were a bug.

Draw an object that makes noise. Draw what you imagine that noise might look like if it could be seen.

Sit in the back of a bus or car and draw your point of view. Feel free to change the scene through the window or make it realistic.

Draw something lit by a candle.

Draw two objects side by side that should never be put together.

Draw two objects side by side that represent opposite themes: War and peace, good and evil, love and hate…

Make a drawing that expresses a lie either literally, figuratively, or symbolically.

Draw an object as if it were in-side-out.

Draw the surface of a coin with a water droplet on it. If you have a magnifying glass, use it.

Draw a soft object with a steel skin with screws, rivets, and bolts.

Draw a cute animal as if it were Frankenstein's pet.

Draw an animal you consider unappealing, as cute.

Draw an object from observation but re-arrange its parts in an unexpected way.

Draw an advertisement for a product you would not like but make it seem appealing.

Draw two objects side by side but change their scale. For example, you might have a giant ant next to a tiny teacup.

Crumple a picture from a magazine and draw it as you see it.

Design a new kind of chair.

Do a line drawing of your shoe, and color it in the way you think would look interesting.

Life is often full of choices. Draw a portrait of yourself, divide the face in half, and show two potential life choices you will need to make as an adult in the design. (You as a teacher or you as a hairdresser) Use symbols and colors in the portrait to show the possible directions your life might take.

Take a common object and draw it as if it was a skeleton. What would the skeleton of a pear look like?

Design a monument for a common object, like a monument to a thumbtack.

Draw a face card from a deck of cards making you the queen, king, jack, or joker.

Draw what you see reflected in a bowl or plate of water. It will reflect better if the bowl is a dark color.

Draw your home or backyard from an aerial perspective. (From above)

Draw a mysterious doorway.

Draw how you would symbolize the 4 seasons.

Design a metal of honor commemorating your greatest achievement in your life so far. If you do not have one you can think of, consider an accomplishment you hope to achieve in the future.

Re-imagine the wrapper for your favorite candy bar. Create a new design for it.

Do a drawing of an object you possess or have nearby, but make it look like its melting.

Draw an object that is reflective. Add a portion of your face into that reflection. (Cell phone, CD, compact, glass of water, spoon, Christmas ball…)

Try to draw an object from 3 points of view but as one object. This is how cubist painters like Picasso and Braque would work.

Find an object and only draw the things around it, leaving the paper white where the object is. We call this negative space drawing.

Scatter a few objects on your table; only draw the parts that overlap.

Draw a landscape with a house, car, or man-made object in it. Give the man-made object natural textures like leaves and grass, and give the natural elements mechanical textures found in the object.

Do a portrait from very careful observation but rearrange the parts of the face.

Create a holiday or birthday card cover in the style of a famous artist.

Do a drawing from observation so lightly that only a person close to the paper can see it.

Draw someone eating, and illustrate behind them, expressive colors, textures, and shapes that you feel would describe the flavor.

Draw the back of someone's head. Try to capture hair without resorting to scribbles.

Draw an eating utensil morphing into something else.

Draw your bedroom as if it was inside a container like a teapot, jar, cardboard box…

Ask the closest person to you pick an object in the area, and then draw it.

Place a few objects on a white piece of paper, only draw the shadows.

Draw what you imagine the inside of your stomach looks like after the last meal you ate.

Imagine you ARE your favorite animal. Do a drawing you think that animal would draw if it could or from its point of view.

Draw a fun pattern for a necktie or bow.

Draw an amazing sand castle on the beach.

Write your initials very large and turn it into a drawing of animals, objects, or other subject.

Draw a new and unique sea creature.

Draw a new and unique dinosaur.

Draw a how-to label or poster for something you know how to do. If it is too complicated, illustrate just 1 to 4 steps of the process.

Draw a simple cartoon that illustrates the last time you were embarrassed.

Draw something with wings that normally would not have them.

Do a drawing of a person combined with an animal. The Egyptians did this a lot.

Create an advertisement for yourself as if you were a product in a store.

Create your initials in a very ornate and decorative way, like old illuminated manuscripts.

Remove your socks and shoes and draw your foot. How would you redesign a common road sign? Yield, Stop, No Running, Poison...

Draw yourself as if you were 100 years old.

Assessment: Graded by both the teacher and the student. Only the teacher's grade counts, but if there is a larger difference between the assessments, they can be discussed.

Project Title _____ Date Complete _____

Short Description _____

Assess a grade of "A, B, C, D or F." You may add + or – if you feel the need.

Student Assessment Below **Teacher Assessment Below.**

Neatness _____ Neatness _____

Completeness _____ Completeness _____

Originality _____ Originality _____

Following Directions _____ Following Directions _____ _____

Meeting Project Goals _____ Meeting Project Goals _____ Recorded Grade

--

Project Title _____ Date Complete _____

Short Description _____

Assess a grade of "A, B, C, D or F." You may add + or – if you feel the need.

Student Assessment Below **Teacher Assessment Below.**

Neatness _____ Neatness _____

Completeness _____ Completeness _____

Originality _____ Originality _____

Following Directions _____ Following Directions _____ _____

Meeting Project Goals _____ Meeting Project Goals _____ Recorded Grade

--

Project Title _____ Date Complete _____

Short Description _____

Assess a grade of "A, B, C, D or F." You may add + or – if you feel the need.

Student Assessment Below **Teacher Assessment Below.**

Neatness _____ Neatness _____

Completeness _____ Completeness _____

Originality _____ Originality _____

Following Directions _____ Following Directions _____ _____

Meeting Project Goals _____ Meeting Project Goals _____ Recorded Grade

--

Project Title _____ Date Complete _____

Short Description _____

Assess a grade of "A, B, C, D or F." You may add + or – if you feel the need.

Student Assessment Below **Teacher Assessment Below.**

Neatness _____ Neatness _____

Completeness _____ Completeness _____

Originality _____ Originality _____

Following Directions _____ Following Directions _____ _____

Meeting Project Goals _____ Meeting Project Goals _____ Recorded Grade

Pass-Points

NAME_____ Period___

This pass may be used in 1 of 2 ways and may not be shared with another student...

#1. You may use this pass to have 1 free class where you choose not to participate. If you are caught not participating, you will be requested to hand in this 1 pass. If all of your passes are used up and you are not participating you may receive a ZERO for that day, and/or a detention. You may not distract others from working when you choose not to work or do something other than a class project.

#2. If NOT USED, this pass can add 10 points to any project or test or replace 1 missing homework.

-- -

Pass-Points

NAME_____ Period___

This pass may be used in 1 of 2 ways and may not be shared with another student...

#1. You may use this pass to have 1 free class where you choose not to participate. If you are caught not participating, you will be requested to hand in this 1 pass. If all of your passes are used up and you are not participating you may receive a ZERO for that day, and/or a detention. You may not distract others from working when you choose not to work or do something other than a class project.

#2. If NOT USED, this pass can add 10 points to any project or test or replace 1 missing homework.

-- -

Pass-Points

NAME_____ Period___

This pass may be used in 1 of 2 ways and may not be shared with another student...

#1. You may use this pass to have 1 free class where you choose not to participate. If you are caught not participating, you will be requested to hand in this 1 pass. If all of your passes are used up and you are not participating you may receive a ZERO for that day, and/or a detention. You may not distract others from working when you choose not to work or do something other than a class project.

#2. If NOT USED, this pass can add 10 points to any project or test or replace 1 missing homework.

--

Pass-Points

NAME_____ Period___

This pass may be used in 1 of 2 ways and may not be shared with another student...

#1. You may use this pass to have 1 free class where you choose not to participate. If you are caught not participating, you will be requested to hand in this 1 pass. If all of your passes are used up and you are not participating you may receive a ZERO for that day, and/or a detention. You may not distract others from working when you choose not to work or do something other than a class project.

#2. If NOT USED, this pass can add 10 points to any project or test or replace 1 missing homework.

PASS POINTS AUTHENTICATION, DO NOT COPY, ORIGINAL MUST HAVE NAME IN COLOR, ALL OTHERS VOID. PASS POINTS AUTHENTICATION, DO NOT COPY, ORIGINAL MUST HAVE NAME IN COLOR, ALL OTHERS VOID. PASS POINTS AUTHENTICATION, DO NOT COPY, ORIGINAL MUST HAVE NAME IN COLOR, ALL OTHERS VOID. PASS POINTS AUTHENTICATION, DO NOT COPY, ORIGINAL MUST HAVE NAME IN COLOR, ALL OTHERS VOID. PASS POINTS AUTHENTICATION, DO NOT COPY, ORIGINAL MUST HAVE NAME IN COLOR, ALL OTHERS VOID. PASS POINTS AUTHENTICATION, DO NOT COPY, ORIGINAL MUST HAVE NAME IN COLOR, ALL OTHERS VOID. PASS POINTS AUTHENTICATION, DO NOT COPY, ORIGINAL MUST HAVE NAME IN COLOR, ALL OTHERS VOID. PASS POINTS AUTHENTICATION, DO NOT COPY, ORIGINAL MUST HAVE NAME IN COLOR, ALL OTHERS VOID. PASS POINTS AUTHENTICATION, DO NOT COPY, ORIGINAL MUST HAVE NAME IN COLOR, ALL OTHERS VOID. PASS POINTS AUTHENTICATION, DO NOT COPY, ORIGINAL MUST HAVE NAME IN COLOR, ALL OTHERS VOID. PASS POINTS AUTHENTICATION, DO NOT COPY, ORIGINAL MUST HAVE NAME IN COLOR, ALL OTHERS VOID. PASS POINTS AUTHENTICATION, DO NOT COPY, ORIGINAL MUST HAVE NAME IN COLOR, ALL OTHERS VOID. PASS POINTS AUTHENTICATION, DO NOT COPY, ORIGINAL MUST HAVE NAME IN COLOR, ALL OTHERS VOID. PASS POINTS AUTHENTICATION, DO NOT COPY, ORIGINAL MUST HAVE NAME IN COLOR, ALL OTHERS VOID. PASS POINTS AUTHENTICATION, DO NOT COPY, ORIGINAL MUST HAVE NAME IN COLOR, ALL OTHERS VOID. PASS POINTS AUTHENTICATION, DO NOT COPY, ORIGINAL MUST HAVE NAME IN COLOR, ALL OTHERS VOID. PASS POINTS AUTHENTICATION, DO NOT COPY, ORIGINAL MUST HAVE NAME IN COLOR, ALL OTHERS VOID. PASS POINTS AUTHENTICATION, DO NOT COPY, ORIGINAL MUST HAVE NAME IN COLOR, ALL OTHERS VOID. PASS POINTS AUTHENTICATION, DO NOT COPY, ORIGINAL MUST HAVE NAME IN COLOR, ALL OTHERS VOID. PASS POINTS AUTHENTICATION, DO NOT COPY, ORIGINAL MUST HAVE NAME IN COLOR, ALL OTHERS VOID. PASS POINTS FORM.

Ordering Supplies

These are the supplies I order for 1 year of both sculpture and a general art classes.

I am given a budget of about 6 thousand dollars every year to supply 150 students that meet daily. My classes average about 20 to 25 students for six 50-minute periods daily. Many companies sell the same materials but have very different pricing. Some offer free shipping. Some offer a percentage off the order if it is over $200. Some offer both. It is well worth your time to comparison shop.

The following are supplies I order on a regular basis.

6 reams of 11 x 17 inch drawing paper
3 reams of 18 x 24 inch paper
3 reams of 11 x 17 watercolor paper
1 ream 18 x 24 watercolor paper
100 16 x 20 inch canvas board
20 doz. Sharpie fine point
20 Doz. Sharpie ultra fine point
6 set Sharpie color pack of 24 (2 varieties)
2 gallon acrylic gloss medium
4 cans clear acrylic spray paint

50 doz. Sargent #2 Pencils
3 pencil sharpeners
1 gross erasers
1 six pen set Sakura
24 rulers 12 inch
6 box latex gloves
1 drying rack
2 packages of "Flawboard" 100 pack
12 packs of ¼ inch dowels
6 cases of plaster craft
12 rolls of 5 lb stovepipe wire, 20 gauge
6 rolls of 5 lb stovepipe wire, 16 gauge
12 long nose pliers with cutter
24 jumbo eye needles, 5 inch
4 rolls of aluminum sheet metal (NOT foil)
2 packs of pipe cleaners, multi-color x1000

6 pint of blockout white acrylic paint
6 pint of acrylic paint Mars Black, ***and all colors you may need. Go heavy on primaries***.
24 sets of water color pencils 24 colors
3 tubes "Kiss off" or other stain remover
2 bulk set of 144 brushes rounds & flats
4 rolls craft paper 1000 ft. x 36 in. 2 white/2 brown
20 sheets of 3/16 foamcore
20 sheets ½ in foamcore
12 X-Acto knives
5 packs of X-Acto blades of 100
12 bottles rubber cement
12 bottles 7.5 oz. Elmer's Glue
6 bottles carpenter's glue
527 glue (good for plastics & metal)
4 box glue stick
4 hot glue guns
400 hot glue refills
60 rolls assorted masking tape
10 bags of casting plaster 25 lbs
1 container of Vaseline 12 oz. (inexpensive release agent for plaster)
2 Rube-r-mold kits
10 packs of 1 oz. cups/ 250 cups (lids?)
5 packs 3.25 oz. cups and lids / 250 cups
5 packs 3.25 oz. cups and lids / 250 cups
10 rolls of aluminum foil 12 in. x 200 ft.
10 bottles speedball ink

If there is enough money I would also order metallic acrylic paints & some spray paint.
Order some tools like hammers, hacksaws, blades, hand-held Fiscar drill & 1 set drill bits.

Often what is purchased in one year can be used the next year. Here is a list of some supplies I recommend.

Craft Sticks / Popsicle Sticks
Junk Brushes (cheap house-painting-like brushes)
Plastic plates
Buckets, sponges, rags
Rubber buckets for plaster work
Disposable aprons
Yarns and string
Nylon kite-type string
Acrylic rods for construction
Scrap or copy paper
Construction paper
Storage bins for wet work
Wood scraps in bulk
Nails, pins and fastening devices
Mirrors, small and or large
Miniature Mannequins
Clips, tacks, binders & folders
Glitter and minimal craft-like items
Speedball pen tips
Clay if you have access to a kiln
Bulk packs of markers, pencils, crayons, oil pastels
Modeling clay (non-hardening)
Drawing boards
Rubbing alcohol
Paint thinner (odorless)

The Tao of Teaching Art

1. Every project must be designed to incorporate the student's life or experience for relevance.
Instead of making a monster, my students might make a gargoyle that would protect them from a specific fear through their choices of symbols, forms, material, and colors. Connect the project to the student experience and they will be invested in the outcome. With this method every project is unique, personal, and expressive.

2. Every project must have a tie-in to core courses.
When we grid—we teach geometry. When we make sculptures—we teach architecture, structure, and engineering. When we teach color mixing—we teach optics and science concepts. When we create illustrations for stories—we teach literature. When we review the styles of art from da Vinci to Warhol— we teach history. Ultimately, we teach creative problem solving and divergent thinking skills. Continue this tradition, and share with students that though this is art, it is also geometry, science, history, etc. Your students will succeed at higher levels in school, and you have a job you can defend against cuts.

3. Every student deserves a little one-on-one time.
Sit with students, one-on-one to learn about their lives, and motivations. Students are better motivated by people they feel care about them.

4. Keep it fun. It's art after all.
Avoid academic exercises and *crafty kitsch*. Do projects you would have liked to have done when you were a child. Silliness, exploration, imagination, and inventiveness help motivate and engage students.

5. Students should plan work with a sketch, a paragraph, or list, and organize ideas with parameters.
This avoids the use of materials you did not intend, waste, and creates a student-generated plan.

6. Flexibility; be ready to change ideas or methods with the tone of the class.
If students seem unmotivated, it may be an indication that you need to switch gears, re-motivate, or ask questions to understand student hesitation. It may also mean production steps were too large, a sample was too vague, or the project should be taught in smaller increments.

7. Love what you do, do what you love, and the students will follow you anywhere.
Children are emotional tuning forks. They can sense if you are *phoning it in*, faking it, or do not really care. Do projects that excite you; share your passion, yourself, and success will be assured.

8. Be dependable, predictable, and a good example.
Plan, prepare, and be consistent. Students do not have to *like you*, but they need to *respect* you. If your expectations are clear, and your classroom management is evenhanded, they will see you as fair. If you need to correct behavior, speak from the heart, and explain why change needs to happen. Corrections starting with "I" are better motivators than demands beginning with "You."

Notes & Ideas:

176

Notes & Ideas:

Notes & Ideas:

Notes & Ideas:

Some Art/Math Answers
NOT in student edition

1. $166.66 4
5. Multiply length by width
6. 70, 70, 166
7. 16 x 21
8. 74 inches or 6 ft 2 in.
9. 216 in^2
10. The ends of rulers are often worn
14. NO: Your materials cost you money.
18. Black has more pigment that is more dense.
19. Different for every brand, you must calculate and use a scale. Weigh white, add black in small amounts till gray is correct, re-weigh and calculate.

We are always looking to make improvements, if you spot errors in this edition you wish to make us aware of, or have a lesson you think should be included, please email the author directly. For significant help, at our digression, we offer a free copy of the book as a thank you. LOVSART@aol.com